POLYMER CLAY
MOSAICS

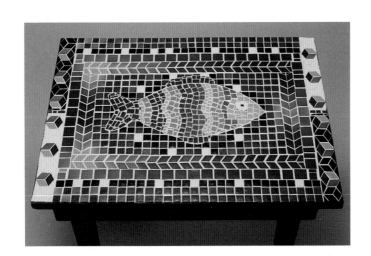

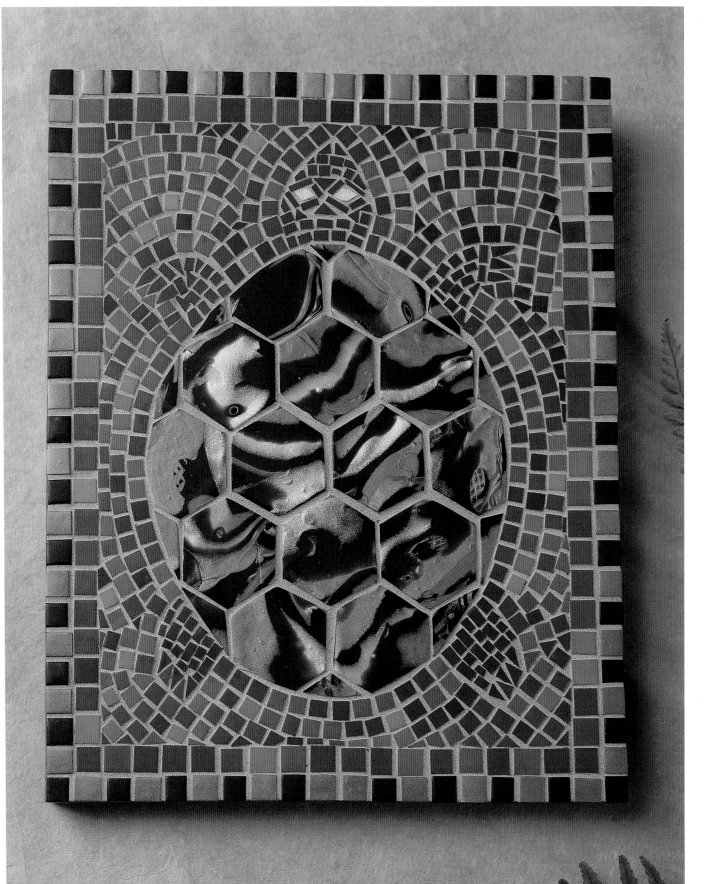

POLYMER CLAY
MOSAICS

Krista Wells

Sterling Publishing Co., Inc.
New York

Prolific Impressions Production Staff:

Editor in Chief: Mickey Baskett
Copy Editor: Phyllis Mueller
Graphics: Dianne Miller, Karen Turpin
Styling: Kirsten Jones
Photography: Jerry Mucklow, Michael Fuller, Julian Beveridge
Administration: Jim Baskett

Library of Congress Cataloging-in-Publication Data
Wells, Krista.
 Polymer clay mosaics / Krista Wells.
 p. cm.
 ISBN 1-4027-0338-4
 1. Polymer clay craft. 2. Mosaics--Technique. I. Title.
TT297 .W48 2004
738.5--dc22

 2003024021

10 9 8 7 6 5 4 3 2 1

Published by Sterling Publishing Co., Inc.
387 Park Avenue South, New York, N.Y. 10016

Produced by Prolific Impressions, Inc.
160 South Candler St., Decatur, GA 30030

Distributed in Canada by Sterling Publishing
c/o Canadian Manda Group, One Atlantic Avenue, Suite 105
Toronto, Ontario, Canada M6K 3E7
Distributed in Great Britain by Chrysalis Books Group PLC
The Chrysalis Building, Bramley Road, London W10 6 SP, England
Distributed in Australia by Capricorn Link (Australia) Pty. Ltd.
P.O. Box 704, Windsor, NSW 2756 Australia

Manufactured in China
Sterling ISBN 1-4027-0338-4

RESOURCES
for Polymer Clay Information

In the United States:

The National Polymer Clay Guild is a non-profit organization based in the United States whose objectives are to educate the public about polymer clay and to study and promote an interest in the use of polymer clay as an artistic medium. Its website has many useful links to resources as well as international guilds. www.npcg.org

In Canada:

Clayamies is an internet mailing list established to promote communication among Canadian polymer clay enthusiasts. It's a great place to ask questions, offer advice and participate in swaps. www.groups.yahoo.com/group/clayamies/

In the United Kingdom:

The website of the British Polymer Clay Guild is www.polymerclaypit.co.uk/polyclay/guild/britpol.htm.

In Australia:

The website of the Australian Polymer Clay Guild is www.polymerclay.com.au/Australian%20Polymer%20Clay%20Artists%20Guild.htm.

In New Zealand:

The website of the New Zealand Polymer Clay Guild is www.zigzag.co.nz/NZPCG/index.html.

The New Clay by Nan Roche (Flower Valley Press) is a comprehensive book of polymer clay techniques. Many artists consider this to be the polymer clay bible.

ABOUT THE ARTIST

Krista Wells

Since graduating university with a Bachelor of English, French, and German in 1988, Krista Wells has led a creative life. For eleven years she toured North America as an actor, but gave that up to operate her business, ArtWare Studio. She produces a feast of fanciful works, from bizarre masks to masterful mosaics, pieces both functional and ornamental.

Her mosaics and other work can be seen in galleries and fine gift shops across Canada as well as in private homes. Since 1998 she's also been the Foley Artist for Salter Street Films, working on everything from science fiction television series and children's animation to award-winning feature films.

Krista Wells lives on the Bay of Fundy in Diligent River, Nova Scotia in a log home built by her partner Michael Fuller, a former theatre director/designer who is now a paragliding instructor. They share their home with their border collie, Isadora Duncan, and more mice than Krista cares to think about. You can contact Krista and see more of her work at www.artware.ns.ca.

Creativity is a type of learning process where the teacher and the pupil are located in the same individual.

Arthur Koestler

ACKNOWLDGEMENTS

I must first thank my partner, **Michael Fuller**, for his general encouragement, both in life and with this book, for his valuable feedback on the book as a whole, and specifically for his photographs in the Techniques section.

My mother, **Marlene Stanton**, gave most welcome editorial assistance and support.

The original Tremblant gang – **Michelle Bourgault**, **Lynda Gould**, **Violette Laporte**, and **Margi Laurin** – were instrumental in my acquiring many of the techniques presented in this book, and we all have **Cathy Simpson**, founder of Clayamies to thank for bringing us together.

Many thanks also go to **Jan Walcott** at **Polyform** for her support and generous supply of Sculpey Premo clay.

Thanks as well to **Julie Scriver** at Goose Lane Editions, **Harry Thurston**, and **Julian Beveridge**.

Dedication

This book is dedicated to Michelle Bourgault – much loved, admired, and missed.

...a la prochaine ma clayamie...

CONTENTS

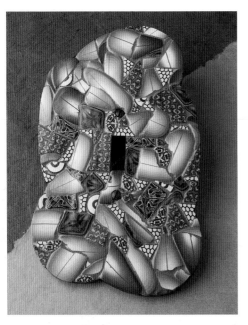

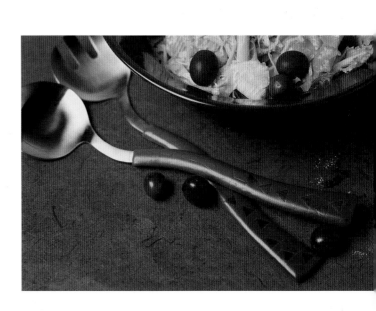

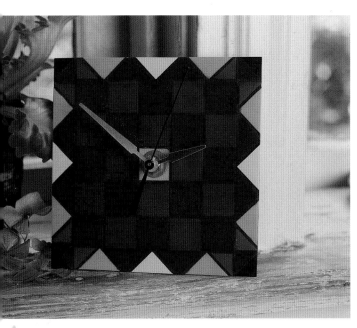

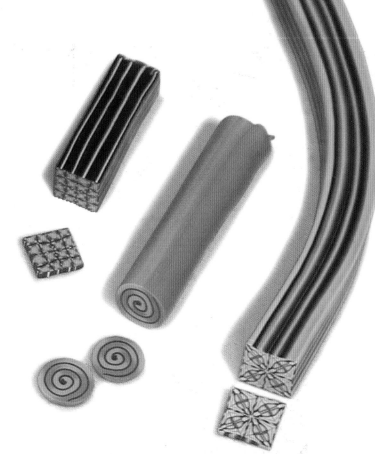

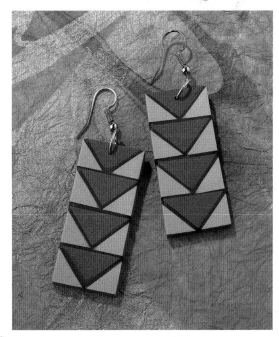

I have a seemingly endless fascination with mosaics. Travels through Spain and Greece in the 1980s and later trips to Portugal fueled my obsession. I've always felt that mosaics were like objects under microscopes in the sense that if you put any object under a microscope and magnify it enough, be it a cross-section of a bug's leg or a drop of water, you see an aesthetically pleasing repetition of elements. When I look at mosaics I imagine they are cross-sections of elements of a giant's life. Mosaics have the power to make me feel very small.

An ancient art ...

Some of the first mosaics were made thousands of years ago, and mosaics have been found worldwide. It seems likely that pebbles and shells were the first materials used to produce mosaics. As the desire for greater artistic expression increased, so too did the need for more refined materials. Eventually a method developed that involved cutting natural stone into regularly-shaped pieces called *tesserae*. The Romans used cut stones to get finer detail in their mosaics, detail that wasn't possible with pebbles and shells. Introduction of stone tesserae was soon followed by glass, glass with gold leaf, and eventually glazed ceramic tiles.

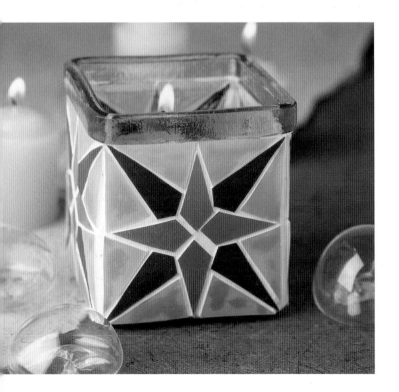

Life is 'trying things to see if they work'.
Ray Bradbury

Leap ahead a few thousand years. The use of ancient materials and methods persists, but there's a new material with which you can do almost anything you would do with stone and tile, and more.

...with a contemporary twist

I've found making mosaics with polymer clay to be very rewarding. The techniques are relatively simple and the clay is incredibly versatile. By making your own tesserae and tiles you have ultimate control over your designs. You're not limited by colors, patterns, or sizes found in commercially available stone, glass, or ceramic. You determine the

size, shape, color, and texture of your tesserae.

In this book, you'll learn relatively simple techniques for creating mosaics with polymer clay tesserae. The projects – more than twenty in all – employ a number of styles so you can get a taste of the myriad possibilities with this amazing medium.

The methods and techniques presented here are by no means the only approach to polymer clay mosaics. Careful study of traditional mosaic techniques as well as your own experimentation will yield more ways to achieve a variety of results.

With a relatively new medium like polymer clay, new techniques develop at a rapid pace. It sometimes happens that two or more people develop the same process independently of each other. Wherever possible, when writing about a technique, I've credited the person I believe developed the particular procedure and/or the person who first introduced it to me. Often, methods are a synthesis of many polymer clay techniques and/or techniques borrowed from other media. Remember that while you may use

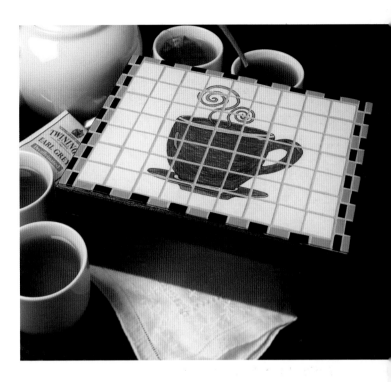

other people's techniques, the pursuit of your own artistic voice is the most rewarding path.

What exactly is a mosaic?

My definition of a mosaic is quite broad – I see mosaics everywhere I look. Any repetition of objects of a similar size or shape or material shouts mosaic to me, and so do arrangements of dissimilar objects, such as those in the method known as *pique assiette*. Andy Warhol's rows and rows of soup cans say mosaic. A parking lot filled with brand-new cars, bumper to bumper, says mosaic. A forest floor littered with spruce cones says mosaic. If you want inspiration, you need only go for a walk and keep your eyes open.

A hunch is creativity trying to tell you something.
Frank Capra

Continued on next page

Inspiration

Inspiration comes in many forms. We can be motivated by anything that affects our senses. It could be a taste, a scent, a sound, a texture, a sight. For visual artists the most obvious inspiration comes from visual stimulus. The natural world is bursting with things to whet our creative appetites. I'm inspired by animals, but for someone else inspiration may come from plants or flowers. Man-made objects can also inspire, whether ancient Roman architecture or the cogs in a discarded clock.

We may also be influenced by other artists. The backsplash project was inspired by Klimt's *The Kiss*. If you look at the original work, you'll see I chose a similar color scheme and echoed the patchwork quality of the color blocks.

Live and Learn

For the purpose of teaching various techniques, I designed these projects for you to copy, but you are always welcome to change the designs to make them more your own. (Ultimately, you'll find that it's more satisfying to do that.)

The projects in this book are not intended to be reproduced by you to sell – they are purely for your personal learning and enjoyment. Once you master the basic techniques you can apply the skills to a diverse range of projects, from small objects to larger works of art. As you become more comfortable with the medium, give your imagination free reign. You'll be delighted by the pieces that you create from your own head and hands.

 reativity is allowing oneself to make mistakes, Art is knowing which ones to keep.

Scott Adams

BASIC SUPPLIES

This section contains information on the basic supplies you'll need for creating polymer clay mosaics. Each project includes a list of supplies you'll need; as you assemble your supplies for a project, you may find it helpful to refer back to this section.

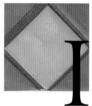Inspiration follows aspiration.

Rabindranath Tagore

Polymer Clay

Polymer clay is a man-made modelling material. Its ingredients include polyvinyl chloride (pvc, the same material plastic plumbing pipes are made of), a plasticizer, and pigments. Unlike ceramic clay, polymer clay can be "fired" by baking in a home oven.

At room temperature, polymer clay is malleable, but once it's baked it becomes rigid. Polymer clay is used by artists and craftspeople to create countless items, from sculptural works of art to fabulous pieces of jewelry. Using polymer clay for mosaics is just one road in an atlas of possibilities.

There are several brands of polymer clay available, each with its own color palette and consistency. Some clay is very stiff and needs a lot of conditioning to get it to a working consistency, and some has a good working consistency straight out of the package. Others are very soft.

With some clay, particularly the very soft type, the finished product can be quite brittle; others produce very durable items. Experiment with brands until you find the one that suits you best. Keep in mind that you can mix one brand of clay with another to create custom colors or to achieve a particular consistency.

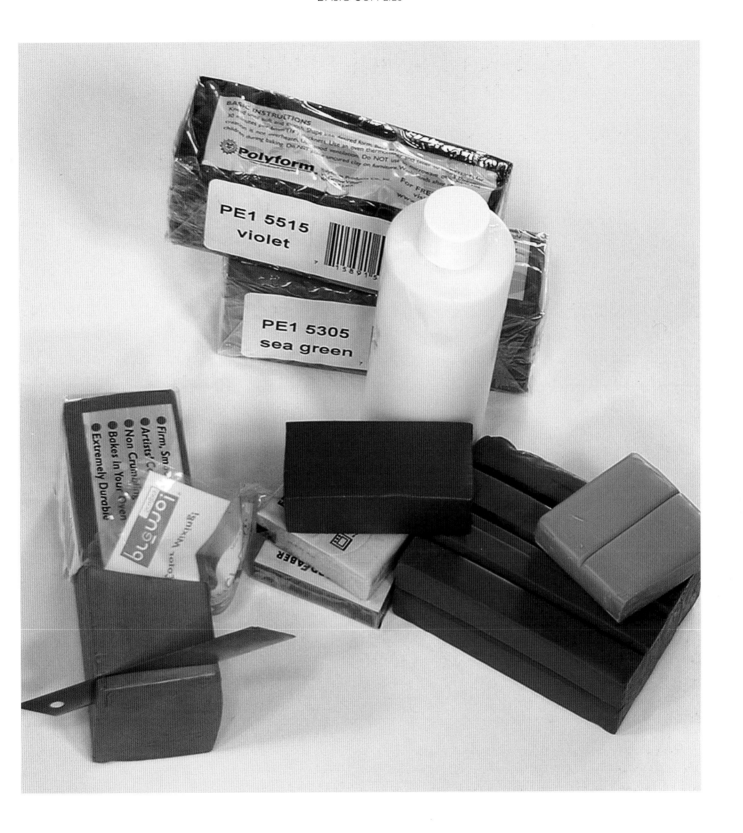

Basic Tools

The tools required for working with polymer clay are few and fairly simple.
The photos on these two pages show the common tools used for the
projects in this book.

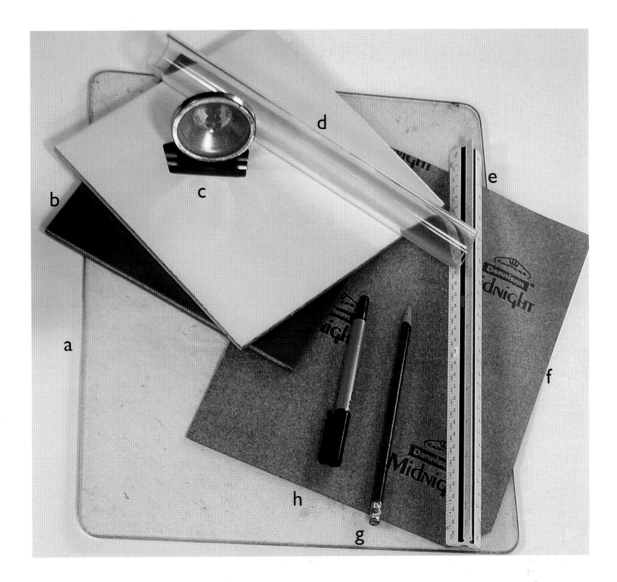

Pictured on page 14, clockwise from top left:

a. **Palette knives** for mixing grout with paint, and for spreading liquid grout

b. **Wooden skewer** for mixing grout with paint

c. **Acrylic roller** for rolling out sheets of clay (A smooth-sided bottle could work as an alternative.)

d. **Assorted wet/dry sandpapers** for sanding completed mosaics (you'll need 280, 400, 600, 800, and 1000 grits) Also shown are **scraps of cardboard** for applying grout.

e. **Cotton swabs** for cleaning excess liquid polymer clay grout and adhesive caulking grout

f. **Waterbase varnish** used as a protective finish on some mosaics

g. **Rubber-tipped sculpting tools** for spreading grout and removing excess grout. They also can be used to sculpt or make a texture on unbaked clay.

h. **Paper cups** for mixing grout with paint

i. **Lint-free cloth** for buffing mosaics

j. **Sponge** for wiping excess grout from mosaics

k. **Needle tool** for piercing unbaked clay

l. **Various drill bits** for making holes in baked clay

m. **Paint brushes** for spreading glue and liquid polymer clay, and for applying paint

Pictured on page 15, clockwise from center left:

a. **Smooth glass cutting board** on which to cut and bake clay

b. **Smooth ceramic tiles** for weighing down sheets of clay so they stay flat during baking and cooling

c. **Oven thermometer** to ensure accurate baking temperature

d. **Acrylic roller** for rolling out sheets of clay (A smooth-sided bottle could work as an alternative.)

e. **Ruler** for measuring

f. **Carbon paper, graphite paper, or transfer paper** for transferring designs to clay and wood bases

g. **Dull pencil** for tracing designs on carbon paper

h. **Fine-tip permanent marker** for tracing over carbon lines after transferring patterns

Cutting and Shaping Tools

Various tools can be used to cut and shape unbaked and baked polymer clay. Here are some examples of tools I used for the projects in this book.

Pictured clockwise from top left:

a. **Self-healing cutting mat** to use as a surface for cutting cardboard or paper, or place a glass cutting board over it and use the grid to measure as you cut clay on the glass.

b. **Cardboard cutting guides** to cut tesserae of specific sizes. (You can make these from matte board.)

c. **Cutters** of various sizes and shapes, for cutting clay tesserae. These can be found where clay is sold.

d. **Linoleum cutter and various shaped gougers** for incising or cutting grooves in baked clay.

e. **Utility knife** for cutting cardboard.

f. **Fine-tip craft knife** for cutting paper templates and to use with templates for cutting clay tesserae.

g. **Large craft knife blade** for cutting polymer clay. This blade can be used instead of a polymer clay blade, but because it's not quite as sharp, the cuts won't be quite as fine.

h. **Ripple blade** for cutting polymer clay across the surface of a sheet to make grooves or straight down to give a rippled edge.

i. **Flexible polymer clay blade** for shaving thin layers of unbaked clay.

j. Slightly **rigid polymer clay blade** for cutting both baked and unbaked tesserae as well as millefiori canes.

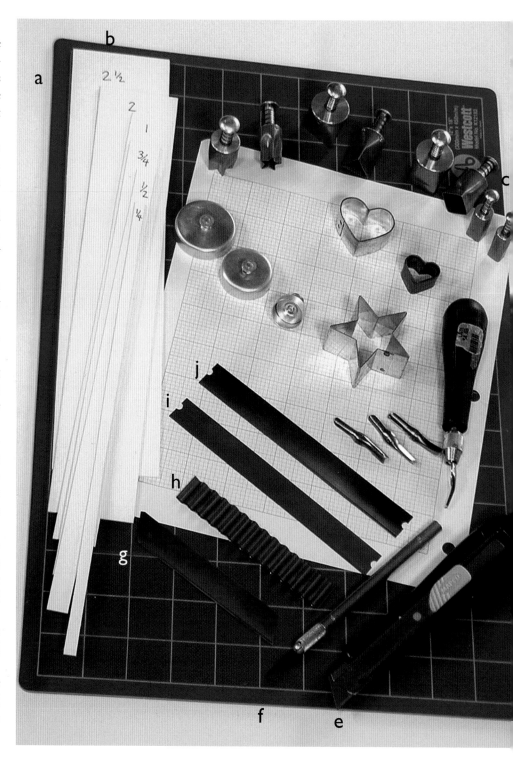

Food Processor and Pasta Maker

These two machines are useful to have when working with polymer clay, although they are not absolutely necessary. *After they have been used to work with clay, these items* cannot be used for food preparation.

A **food processor** is useful for conditioning or kneading large quantities of the stiffer brands of clay. **Caution:** If you do use a food processor for clay, you must dedicate a separate bowl, cover, and blades for working with clay.

The **pasta maker,** a hand-cranked machine that is used for making sheets of pasta dough, makes it easy to produce sheets of clay that are uniform in size and thickness – it's the workhorse for many projects. Instead of using a pasta maker, you can roll fairly even sheets of clay with an acrylic roller or a smooth bottle if you use stacks of cardboard along the edges of your clay so that the roller can't press down any farther than the thickness of stacked cardboard.

Pasta Machine Setting Chart

Pasta machines vary from brand to brand. On some brands the thickest setting is #1 while on others #1 is the thinnest setting. The projects in this book use a common brand with the following settings.

Setting #	Inches	MMs
1	1/8	3.2
2	3/32	2.4
3	5/64	2
4	1/16	1.6
5	3/64	1.2
6	1/32	.8
7	1/40	.6

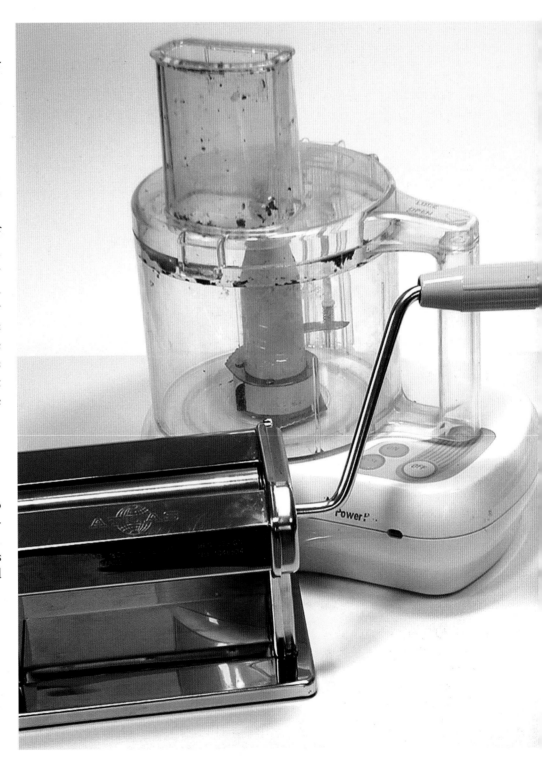

Glue

Choose the glue you use according to what's needed for the particular project.
Individual project instructions list the glue I used for that project.

Polyvinyl acetate (PVA) glue is a white glue available at hardware stores. Use it to bond baked tesserae to wood and to bond unbaked polymer clay to plastic or metal. It cleans up easily with water.

Cyanoacrylate glue (often called "super glue") will bond baked polymer clay to metal, glass, or baked polymer clay. Clean the metal with rubbing (isopropyl) alcohol before applying the glue. This glue won't hold if baked, however – so always use it *after* baking.

Phenolic vinyl adhesive caulking can be used as a grout or as a glue. It works well for bonding larger wood panels and other common building materials to vertical or horizontal surfaces.

Grout

For the projects in this book I've used three types of grout. There are other options;
after you're more experienced, you may want to experiment to see if other types
of grout suit you.

▦ Premixed Siliconized Tile Grout

This is a ready to use grout for walls and countertops. It comes in a variety of colors; I like to buy either white or silver-gray so that I can tint the color as needed, in small batches.

To tint, use a bit of acrylic paint, but don't expect to get a deep color. (If you use enough paint to produce a deep-colored grout, the strength of the grout would be jeopardized.) If your design requires a grout with a deep color, use a commercially tinted grout.

This standard type of grout is fairly easy to clean off the mosaic surface after application and since it cures at room temperature, the size of your project isn't limited to the size of your oven. Standard grout is also readily available at hardware stores and building supply centers and is less expensive than the alternatives.

▦ Liquid Polymer Clay

This can be used for grouting if your project is small enough to fit in your oven and if the project base can withstand the baking process. (Wood bases, for example, can warp in the oven.) Find it at crafts stores and places where polymer clay products are sold.

Liquid polymer clay is available in translucent and a variety of colors. To tint the translucent type, add a tiny amount of oil paint or a pinch of colored polymer clay. Use a small palette knife, wooden skewer, or craft stick to mix the liquid clay with paint or clay in a small paper drinking cup or on a scrap of waxed paper.

The advantage to using liquid clay as a grout is its great ability to bond to polymer clay. Until it's baked it has no strength, but once baked it bonds securely. This ability to bond can be a disadvantage, since sanding off the excess grout after curing is difficult.

■ Phenolic Vinyl Adhesive (PV) Caulk

This product can also be used for grouting. I chose it for its ability to bond to glass, but it works on all common building materials and cleans up with water. One disadvantage is its stickiness. Another is that it is difficult to tint. It can, however, be painted with latex, acrylic, or oil paint after curing. Because this product remains flexible even after curing, I don't recommend it for projects that you plan to sand after grouting. The residue created by sanding could get embedded in the grout. Find it at hardware stores and building supply centers.

Finishes

There are several choices when it comes to finishing your mosaics; the finish I recommend for each project is included in the individual project instructions. Here are some I commonly use:

■ Varnish

Use for durability and a high shine.

The most important factor when choosing a varnish is that it be waterbased because varnish-type coatings that are not waterbased are incompatible with polymer clay. Choose a clear finish in your desired sheen (matte, satin, or gloss) and follow the manufacturer's instructions for application and drying times. Typically, these finishes are intended for use on wood; find them at hardware, paint, and crafts stores

■ Nothing at all

Sometimes less is more. See the Ancient Ruin project for an example.

■ Liquid Polymer Protectant

Use for moderate protection and a soft luster.

This product is sold as a protectant for vinyl, rubber, and plastic. It's easy to apply and works well for brightening the colors of the tesserae without adding too much shine. Find it auto supply and hardware stores.

■ Pure Elbow Grease

Creates a subtle glow.

Buffing with a soft, lint-free cloth after sanding leaves your mosaic with a natural look, especially if you've used earth-toned clays.

BASIC TECHNIQUES

This section includes information on the basic techniques for making polymer clay mosaics – conditioning clay, cutting tesserae, baking the clay, gluing, grouting, sanding, and finishing.

SAFETY FIRST

Although polymer clay is certified non-toxic, there are certain precautions you should take.

• When working with clay, **don't** use any utensils or work surfaces that will be used for food. *This includes glass cutting boards.*

• **Don't** use containers made of polymer clay to store food.

• When baking your clay, **be sure the oven doesn't get too hot.** If by some accident the polymer clay burns, ventilate the room immediately and get out until the air is clean again.

• **Protect your hands.** Some artists wear latex gloves when working with polymer clay to ensure that none of the plasticizer or pigments soak into their skin. I find gloves awkward so I rub a barrier cream into my hands before working with the clay. When I'm finished working, the clay washes off easily with soap and warm water. *Tip:* If the clay is really persistent, I use a bit of baking soda with water.

Conditioning the Clay

Each brand of clay has its own particular consistency – some are firm, some are less firm. For clays that aren't as stiff you can begin working with them almost immediately, but to achieve good results with firm clay, you must condition the clay until it has an even consistency. You can condition clay with your hands, with a food processor, or with a pasta maker.

■ Conditioning by Hand

1. Chop firm clay into little pieces about the size of peas. This can be done with a 4" craft blade or in a food processor that is dedicated to craft pursuits. (**photo 1**)

2. Pick up a handful of the chopped clay and squeeze it into a lump. (**photo 2**)

3. Continue to knead and work the clay with your hands (**photo 3**) until you can roll it into a long snake (**photo 4**). Then fold the clay snake back on itself (**photo 5**), twist (**photo 6**), and repeat until the clay has an even consistency (or an even color if you're mixing colors).

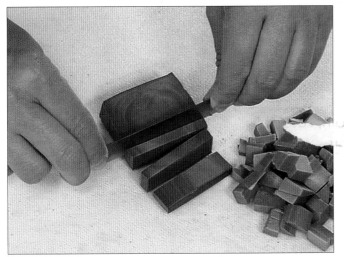

Photo 1 - Chopping clay with a blade.

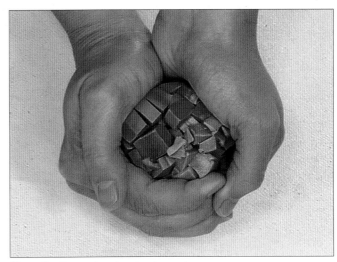

Photo 2 - Squeezing the clay into a lump

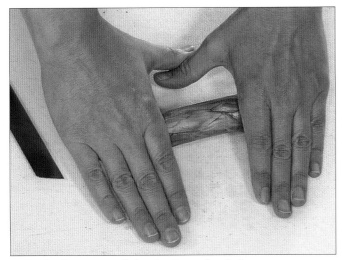

Photo 3 - Starting to roll the clay into a "snake."

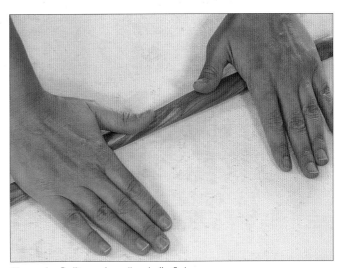

Photo 4 - Rolling a long "snake" of clay.

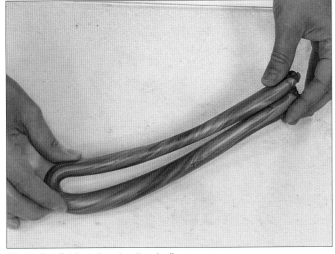

Photo 5 - Folding the clay "snake."

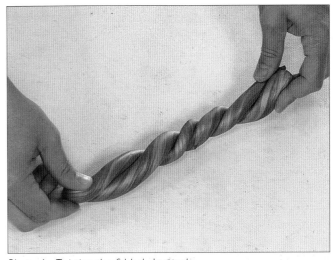

Photo 6 - Twisting the folded clay snake.

■ Conditioning with a Pasta Maker or Roller

1. Slice thin slabs of clay directly from the block and run them through the pasta maker. (**photo 1**) If you don't have a pasta maker, use a roller or bottle to do the same thing. (**photo 2**)

2. Fold the flattened clay and run it through the pasta maker again. (**photo 3**)

3. Repeat (**photo 4**) until the sheet of clay has an even consistency or color (**photo 5**)

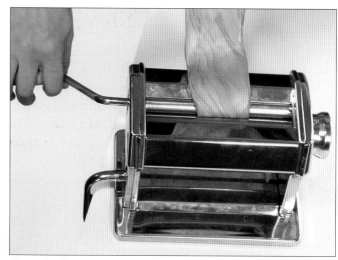

Photo 1 - Running a thin slab of a mix of colors of clay through the pasta maker.

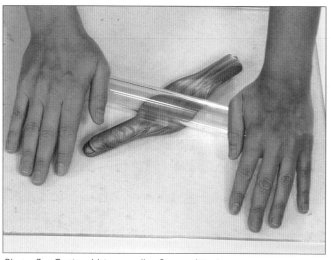

Photo 2 - Option: Using a roller for conditioning.

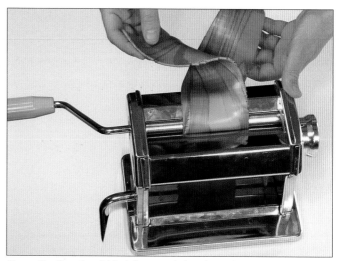

Photo 3 - Running folded, flattened clay through the pasta maker again.

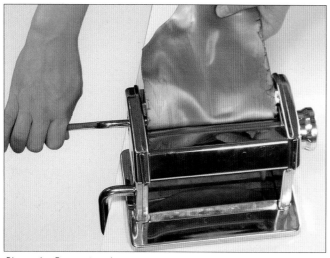

Photo 4 - Repeating the process.

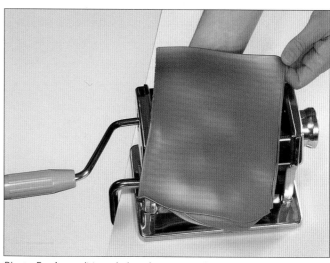

Photo 5 - A conditioned clay sheet.

Storing Unbaked Clay

Once clay has been conditioned, it can be stored for a few days before it loses its working consistency. (If stored longer than that, it will need to be conditioned again.) I recommend storing conditioned clay in flat sheets – with waxed paper between the sheets of clay to prevent them from sticking to each other – in plastic sandwich bags or plastic containers.

When you're ready to use a sheet, roll it through the pasta maker once or twice, and it's ready to work with again.

Cutting the Tesserae

Tesserae are any material – such as stone, glass, ceramic, polymer clay – cut into small pieces to be used in mosaics. The term is often used interchangeably with "tile."
A tessera is a single piece of tesserae or a single tile.
For the most part, the projects in this book use tesserae made from sheets of clay. How you turn those sheets of clay into specific tesserae depends on the project. What follows is a series of methods for cutting tesserae. Choose the method appropriate to the project.

Instructions begin on the following page.

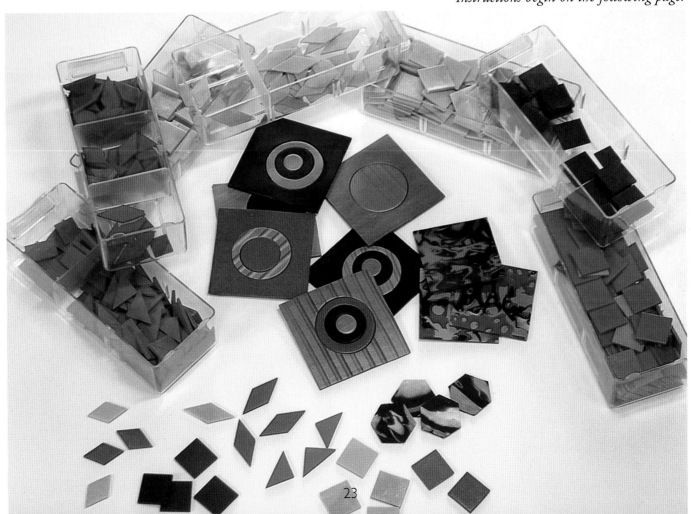

23

continued from page 23

For best results when cutting tessarae, use a glass cutting board – there are numerous advantages.

• Unbaked clay tends to stick to the glass, preventing the clay from stretching out of shape as you cut.

• You can leave the clay on the glass and bake it without having to transfer it to another surface. (The less you handle the unbaked tesserae, the less likely they are to get distorted.)

• Don't worry if the edges of the tesserae are touching each other. Once they've been baked, you can easily cut or snap them apart.

■ Using Cardboard Cutting Guides

To cut large quantities of equal-sized tesserae, use a cutting guide made from stiff non-corrugated cardboard such as matte board. I keep a variety of cutting guides on hand, including 1/4", 1/2", 3/4", 1", 1-1/2", 2", and 2-1/2".

Here's how to make and use a cutting guide:

1. To make the cutting guide, cut a strip of cardboard 10-12" long and the same width as the tesserae you want to cut.

2. Smooth a sheet of clay on your glass cutting board. Avoid trapping pockets of air between the clay and the glass.

3. Lay the cardboard guide on the sheet of clay. Using it as a guide, drag your blade along the edge and cut several 3/4" strips. Leave the strips on the glass. If they moved

Using a cardboard cutting guide.

while you were cutting them, line them up evenly again.

4. Position the guide at a right angle (90 degrees) to the cuts you just made, and cut again to make squares. Move the guide along the length of the strips as you work, lining the edge with the previous cut.

■ Using Graph Paper or Grid Patterns

Use graph paper for cutting rectangles, or squares, and grid patterns for cutting diamonds or triangles.

With graph paper:

1. Place a sheet of graph paper under your glass cutting board.

2. Make a sheet of clay slightly smaller than the length of your long craft blade or polymer clay slicing blade.

3. Smooth the sheet of clay onto the glass. Avoid trapping any pockets of air between the clay and the glass.

4. Line up the ends of the blade with the grid and cut straight down. Don't drag the blade.

With a grid pattern:

1. Use a cardboard cutting guide to cut strips of clay to the desired width.

2. Make a photocopy of the grid pattern.

3. Place the cutting board over the photocopy, lining up the clay strips with the long parallel lines of the diagram.

4. Use the short parallel lines to line up your blade. Press the blade down – don't drag it – to cut.

■ Using Templates

1. Make the template by photocopying the pattern on cardstock or gluing a paper copy on cardstock or cardboard, and cut out the shapes.

2. Smooth the sheet of clay on the glass cutting board. Avoid trapping pockets of air between the clay and the glass.

3. Position a template on the clay. Holding it down with one hand, cut around the shape, using a fine-tip craft knife.

4. Peel away the surrounding clay, leaving the tessera stuck to the glass.

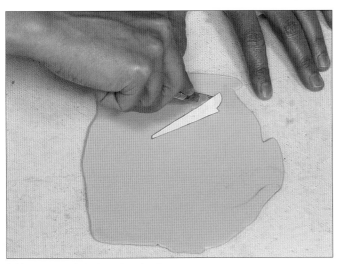

Using a template to cut out a tessera.

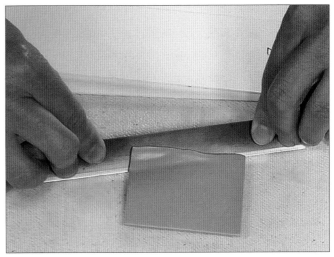

Lifting clay from glass with a blade.

TIPS

- With intricately shaped tesserae (like the ones used in the Art Deco Shelf), it's particularly important to cut them out on the glass surface. This way you can avoid handling them until they're baked, reducing the risk of stretching them out of shape.

- If the project requires you to pick up the tesserae to work with them before they've been baked, slide a blade under the shape and peel it off the glass

- *Option:* Instead of cutting the shapes on glass, put the sheet of clay on paper and cut the shapes. They will lift off the paper easily.

The beginning is the half of every action.

Greek Proverb

Drilling Holes

Making a hole in polymer clay can be done before it's baked simply by piercing it with a sharp object. Once tesserae are baked, holes can be made with a power drill, a hand drill, or – if the hole isn't extremely large – simply by holding a drill bit in your fingers and twisting it through the clay. (This is particularly easy if you've made a small pilot hole before the clay was baked.)

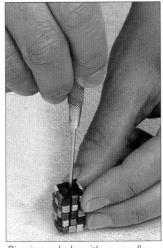

Piercing a hole with a needle tool.

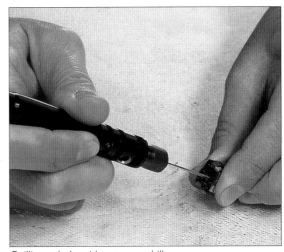

Drilling a hole with a power drill.

25

Baking (or Firing) the Clay

Polymer clay can be baked in a home oven, a toaster oven, or a convection oven. Recommended baking temperatures and times vary slightly from one brand of clay to the next. I've had consistent success baking at 275 degrees F. Before baking, you must test your oven for accuracy.

▦ Testing Your Oven

Be sure your oven temperature is accurate and that the temperature remains consistent throughout the baking process. Here's how to calibrate your oven temperature:

1. Place a stand-alone oven thermometer in the oven. Set the oven dial to 275 degrees F.

2. Check the reading on the stand alone thermometer every five minutes for at least 45 minutes. Take notes of the temperatures.

3. Note when the oven levels out at the correct temperature. This is when you put the clay in the oven. If the correct temperature is never reached, repeat the process, adjusting the dial accordingly until you discover where it needs to be set to reach 275 degrees F.

Some ovens do what is called "cycling," where the oven's heating elements turn on and stay on for a short while even after the correct temperature has been reached, causing the temperature to spike above the set temperature. Then the heating elements turn off, and the temperature drops below the set temperature. Eventually, the heating elements turn on again and overheat the oven. If, during cycling, the temperature spikes by more than 10 degrees F, your clay could

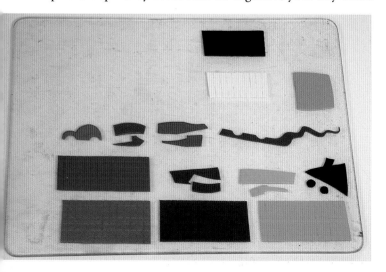

burn. If your oven does this, **do not** use it for polymer clay.

▦ Baking Considerations

- **Bake on glass.** I bake clay directly on a glass cutting board or on sheets of paper (for information on using paper, see "Baking in layers"). When baked on glass, the clay will have a shiny area where it touched the glass – that won't matter since only one side of the clay will be seen in your mosaic.

- **Use paper for a matte look.** If you don't want a shiny area on the clay, bake it between sheets of white paper and place a smooth ceramic tile on top to keep the clay flat. (Paper has a tendency to wrinkle in the heat, causing clay sheets warp.)

- **How long?** The length of time required to bake a piece of clay varies with the thickness of the clay. Baking clay longer than recommended doesn't really harm it and can actually make it stronger, but some clays tend to darken, so be aware of this possibility.

- **Re-baking.** You can also bake clay more than once, which is useful when you want to add unbaked clay to baked clay. Press the unbaked clay to the baked pieces and they will fuse when baked. Clay can be re-baked as often as necessary.

- **Baking in layers.** The one thing you **must not do** is place layers of unbaked tesserae directly on top of each other – they will fuse. If you don't have room on your glass board for all the tesserae you want to bake, do this:

1. Place the overflow on a sheet (or sheets) of white paper.

2. Place the paper with the clay on top of the clay that's on the glass. If you have more than one, place it on top of the first. Stack the layers of tesserae, separated by sheets of paper.

3. Place another sheet of white paper on top. Place a ceramic tile, smooth side down, on top of the paper to keep it all flat.

Cutting Baked Tesserae

You can cut baked tesserae with a fine point craft knife or a long blade. To cut irregular shapes, draw the craft knife through the tessera. You can make straight cuts by pressing down firmly on the tessera with a long craft blade or polymer clay blade. The tesserae will cut with a snap.

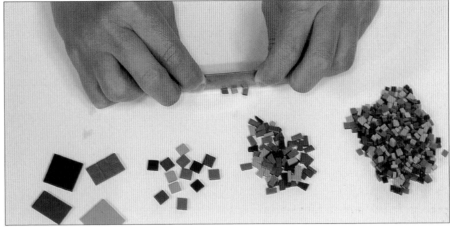

Cutting baked tesserae.

Transferring Designs to Surface

When gluing the tesserae to a surface such as a piece of wood, it may be easier if you first transfer the overall design to the surface so you have a pattern to follow.

Here's how:

1. Trace or photocopy the pattern from the book.

2. Place a piece of carbon paper, transfer paper, or graphite paper, ink side down, on the surface on which you want to transfer the design.

3. Place the tracing or photocopy of the design face up on the carbon paper.

4. Using a dull pencil, trace over the lines of the design.

5. Lift the pattern and the carbon paper to see if the design is transferring. Be careful not to shift the papers during this process. *Tip:* It's a good idea to tape the carbon paper in place, then tape the photocopy on top.

6. Once you have the whole design transferred, remove the papers.

7. If you want to darken the carbon lines, trace over them with a fine-tip permanent marker.

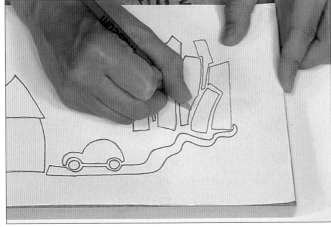

Transferring a pattern to wood.

Checking to see if the design is transferring.

Gluing Tesserae to a Surface

The type of glue you use for a project depends on the surface to which tesserae are to be attached – the type of glue needed for each project is included in the individual project instructions. For more information about glues, see the Supplies section.

Applying glue to ("buttering") the back of a tessera, using a rubber-tipped sculpting tool. A piece of wax paper holds a small puddle of glue.

Pressing the tessera in place on the surface.

Grouting the Project

■ Using Tile Grout

Premixed siliconized tile grout is readily available and easy to use. You can buy pretinted grout or tint white or light gray grout to the color of your choice by adding a little acrylic paint. If you want a deep color, it's best to buy pre-tinted grout; you can't get a really deep color by mixing with paint.

1. Use a scrap of heavy cardboard (1-1/2" x 3") to spread the grout across the tesserae, working back and forth, pushing the grout into the spaces between the tiles. Hold the cardboard at a 30 degree angle and drag diagonally.

2. When all the spaces are filled with grout, use a clean piece of cardboard or a rubber-tipped sculpting tool to lightly remove the large amounts of excess grout from the surface.

3. Wait 30 minutes. Wipe the surface with a barely damp sponge. Rinse the sponge frequently in a bucket of water. Be careful not to apply too much pressure – that could pull out the grout. Do a final pass with a dry, lint-free cloth. Allow to cure for 24 hours.

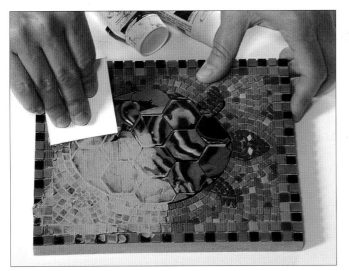

Spreading grout.

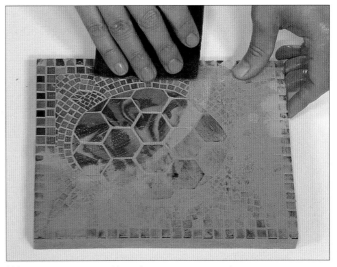

Wiping away grout with a damp sponge.

◼ Using Liquid Polymer Clay

Use liquid polymer clay only if your project will fit in your oven *and* if the base can withstand baking. (Wood tends to warp, for example.) Liquid polymer clay is a good choice for most jewelry pieces. Tint it with a tiny amount of oil paint or a pinch of colored polymer clay.

1. Use a small palette knife, rubber-tipped sculpting tool, or a scrap of cardboard to spread the liquid clay into the spaces between the tesserae.
2. Clean excess grout from the surface of the mosaic, first with the sculpting tool, then with a cotton swab dipped in rubbing alcohol. Be careful not to draw the grout out from between the tesserae.
3. Bake at 275 degrees F. for 20 minutes. Remove from oven and allow to cool.

◼ Using Vinyl Adhesive Caulk

Phenolic vinyl adhesive caulking is a good choice for mosaics on a glass base.

1. Using the smooth edge of a plastic knife, spread the caulk between the tesserae.
2. Wipe off the excess with a slightly damp cotton swab as you work, keeping the surface of the mosaic free of the caulk as you go. Be sure to have cleaned the entire mosaic surface before the caulk starts to set, which happens within 10 or 15 minutes.
3. *Option:* Paint after curing with latex, acrylic, or oil paint.

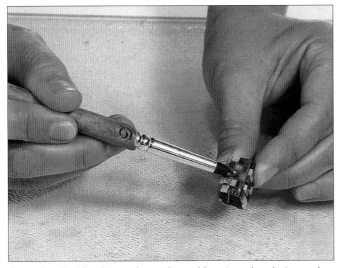

Spreading liquid polymer clay with a rubber-tipped sculpting tool.

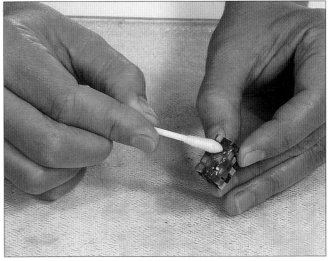

Removing excess liquid clay grout with a cotton swab.

Sanding the Grout

Sanding will remove excess grout that has dried on the surface of your tesserae. Sandpaper with lower grit numbers removes the excess grout, but it also creates scratches on the surface of the tesserae. Sandpaper with higher grit numbers eliminates the scratches. (Finer sandpapers still scratch, but the scratches become too fine to detect.)

With sanding, it's important that you don't skip any steps. Here's the sanding procedure I use:

1. Dip a piece of 280 grit wet/dry sandpaper in a bucket of water. Sand the entire surface of the mosaic, using a circular motion. Rinse the sandpaper frequently.

2. Repeat, first with 400 grit, then with 600 grit, then with 800 grit, and finally with 1000 grit. Use a fairly light touch as you sand, and wipe off excess water as necessary.

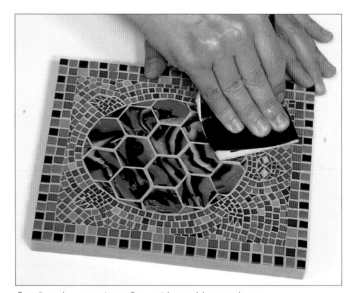

Sanding the mosaic surface with wet/dry sandpaper.

Buffing

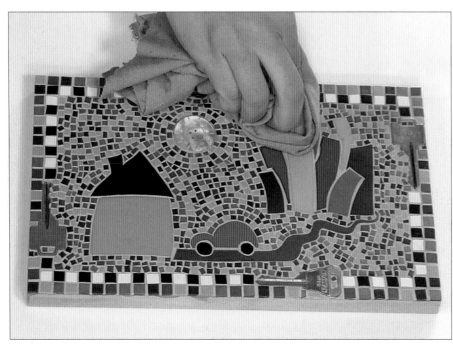

Finish the sanding process by washing down the mosaic with a cloth and clean water. Buff dry with a clean, lint-free cloth.

Buffing a sanded mosaic with a clean cloth.

Finishing

There are several choices when it comes to finishing your mosaics. One option is to apply a clear waterbase varnish – simply follow the varnish manufacturer's instructions. Another is to simply buff and leave as is. A third alternative – one I use frequently – is to polish the surface with a liquid polymer protectant liquid. You can reapply the polish whenever your mosaic needs a lift.

1. Spray a mist of polymer protectant on the mosaic surface.

2. Spread the liquid over the entire surface with a paper towel. Allow to dry for half an hour. Spray again and allow to dry for another half hour.

3. Buff the surface with a clean paper towel, removing any excess.

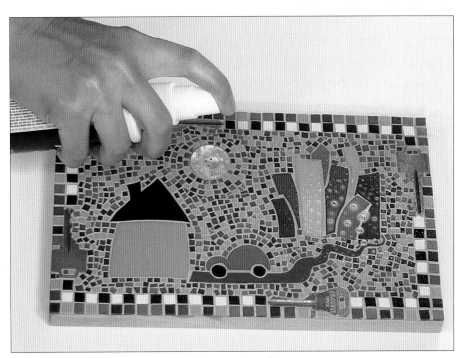

Spraying liquid polymer protectant on the mosaic surface.

You've gotta be original, because if you're like someone else, what do they need you for?

Bernadette Peters

GOING BEYOND THE BASICS

The techniques in this section provide a number of creative choices when it comes to designing your tesserae. Choosing one – or more – of the following can greatly affect the final look of your mosaic.

Some painters transform the sun into a yellow spot, others transform a yellow spot into the sun.

Pablo Picasso

Color Mixing

Don't be limited by using only the colors straight from the package. Mixing colors is very satisfying and leads to many new possibilities in your designs. When you start playing with different combinations, you may come up with colors you've never imagined.

I like to keep a color chart, complete with formulas, of various colors that I mix. Some of my favorites include a metallic avocado green (metallic green + gold) and a rich golden red (cadmium red + gold). Another is pearl, violet + a bit of cobalt blue.

Pictured at right: Color Samples

32

Inclusions

Many things can be added to polymer clay to give it more texture and/or color —
bits of herbs, spices, crayons, paper, or dirt. They are called inclusions. Anything that
can withstand the baking temperature can work, although material with moisture can
cause air bubbles to form in the clay as the moisture evaporates. Be aware that as
you add foreign material to your clay its strength diminishes — but small amounts of
material shouldn't cause a problem. For an example of tesserae with inclusions, see
the Ancient Ruin Fragment project.

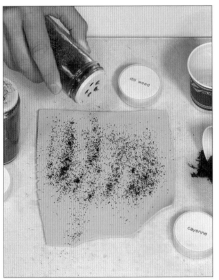

Here's how to add inclusions:

1. Roll out a sheet of clay and sprinkle the material on top. (**photo 1**)

2. Use an acrylic roller or smooth-sided bottle to roll the bits of material into the clay. (**photo 2**)

3. Fold the sheet (**photo 3**) and roll it flat (**photo 4**). Continue to fold and roll the clay until the material is evenly distributed throughout the clay. (**photo 5**)

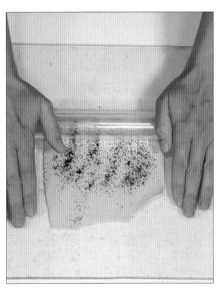

Photo 1 - Spreading inclusions on clay.

Photo 2 - Rolling inclusions into clay.

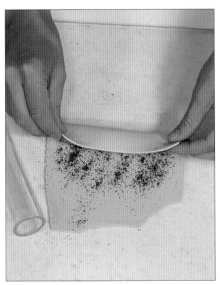

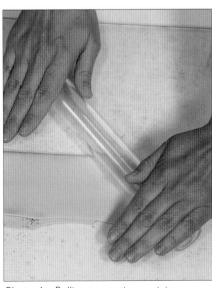

Photo 3 - Folding the clay.

Photo 4 - Rolling to continue mixing.

Photo 5 - Clay with inclusions incorporated.

Making Millefiori or Canework

Millefiori, an Italian word that literally means "a thousand flowers," is an ancient technique that originally used glass rods in an assortment of sizes and colors — the rods were bundled together to form an intricate pattern and fused. A cross section was then cut from the bundle (called a cane), and fused to a glass bead.

Polymer clay easily lends itself to this technique. Intricate abstract patterns can be made quickly by randomly placing rods, sheets, snakes, etc. of different colored clays in a bundle and pressing them together forming a cane.

There are excellent books and websites devoted to the art of polymer clay millefiori. What follows is a quick lesson to get you started.

Although the shapes of the pieces of clay making up the cane can be chosen without fear of mistakes, the same can't be said of color choice. Here are some tips:

• Placing contrasting colors side by side will give high definition of the pattern. Colors with less contrast can be used, but the pattern will be more subtle.

• If you place two pieces of clay of the same color side by side, there will be no definition — when you press the bundle together they will appear as one section, not two. To avoid this, outline the colored rods by wrapping them in a thin sheet of contrasting color.

• Firmer clays yield canes with crisper designs. Soft clays tend to produce muddy images and more distortion when sliced.

■ Making a Round Cane

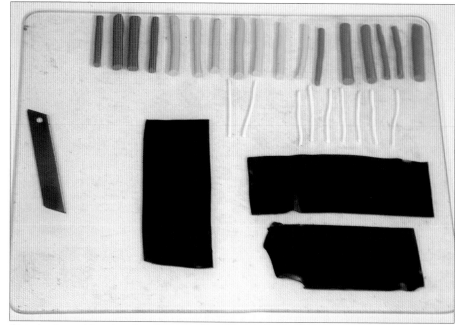

Step 1 - Assembling the clay elements for a cane.

Step 2 - Wrapping a log with a thin clay sheet.

Step 3 - Cutting away the excess clay sheet.

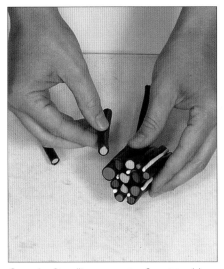

Step 4 - Bundling a group of wrapped logs together.

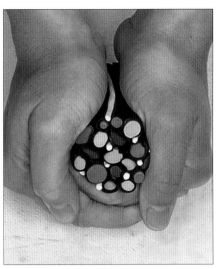

Step 5 - Squeezing the bundled logs together to form a cane.

Step 6 - Stretching the length of the cane reduces the diameter. If your cane is round, roll it between your palm and the glass cutting board to lengthen it.

Step 7 - As the can gets longer, use both hands and continue rolling. When it reaches the desired diameter, allow the cane to rest 24 hours to become firm again before slicing.

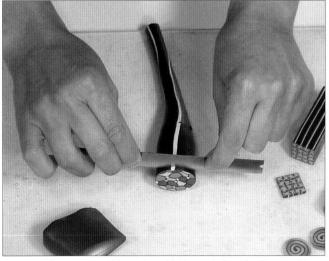

Step 8 - Slicing canes. Use a long blade and slice slowly straight down. Don't draw the blade back and forth.

■ Making Canes with Flat Sides

If you have a cane with flat sides (square, rectangle, triangle), place it on the glass and press the face-up sides with one hand while carefully stretching the cane from the end with the other hand. Flip the cane and repeat, continuing until it reaches the desired size.

■ Making Canes with Fine Details

If you want an abstract pattern with very fine detail, cut the cane into four equal lengths. Bundle together as you did the solid colored rods of clay. Roll or press to reduce the bundle. For even finer detail, keep reducing, cutting into rods, and bundling until you're pleased with the pattern.

For an example of using a variety of cane slices as tesserae, see the Gaudi-Inspired Switchplate project.

Color Gradation

Color gradation is a method for making sheets of clay in two or more colors where the colors gradually shift or shade from one to the next. (Most polymer clay artists know this type of color gradation as the Skinner blend – named for Judith Skinner, who generously shared her technique.) For examples of using gradated tesserae in mosaics, see the Gecko Door and Timeless Turtle projects.

Here's how to create a sheet with color gradation:

1. Choose two or more colors of clay. When choosing colors keep in mind what the result will be when you mix one with the next. If you choose yellow and blue, for example, the middle area will be green. Red and green will produce a muddy brown-colored middle area.

2. Roll each color into a sheet at the thickest setting on the pasta maker.

3. From the sheets of clay, cut a triangle of each color.

4. Butt the colors together to form one sheet and run the sheet through the pasta maker at setting #3. (**photo 1**)

5. Fold the sheet (**photo 2**) and run the clay run through again, folded edge first.

6. Repeat Step five 20 to 30 times, until your sheet gradually shades from one color to the next. (**photo 3**)

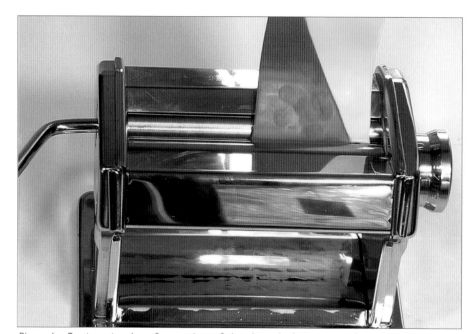

Photo 1 - Putting triangles of two colors of clay through the pasta maker.

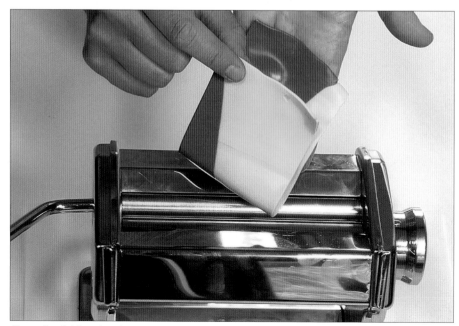

Photo 2 - Folding the sheet.

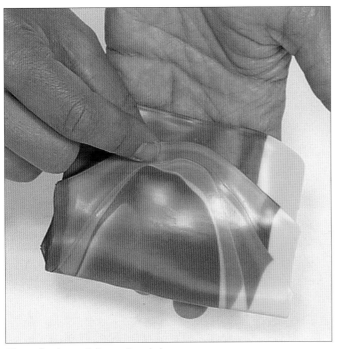

Photo 3 - A partially gradated sheet.

7. Once you have a shaded sheet, you can make the color change take place over a greater area by folding the sheet and running it through at the #2 setting; then fold it the same way and run it through at the #1 setting. (This is making your sheet thicker.)

8. Set pasta maker on the #4 setting. Turn the sheet 90 degrees. Don't fold it. Run it through the pasta maker with the solid colored edge, not the gradated edge, first. (**photo 4**)

9. Now you can cut tesserae from this sheet. [photo 5 - gradation ready to cut into tesserae)

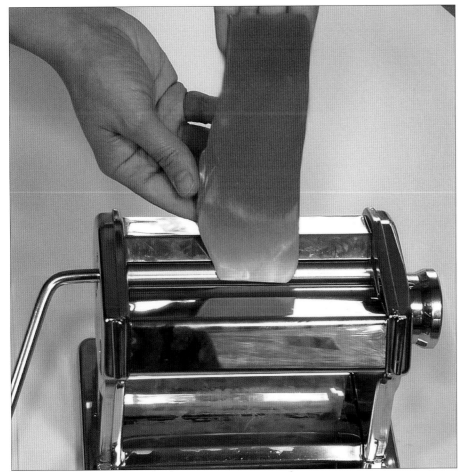

Photo 4 - Making gradation longer.

Photo 5 - A gradated sheet.

Adding Texture

You can create texture on polymer clay in a variety of ways. Simply pressing an object on the clay leaves an impression. You can roll a flat object (such as a piece of fabric or a commercially produced plastic texture plate) on the clay, either with a roller or by passing both clay and object through the pasta maker together.

Depending on the object, there's a possibility the clay might stick to it. If this is the case, spritz the object with a fine mist of water before pressing it into the clay. Pat the clay dry with a paper towel afterwards.

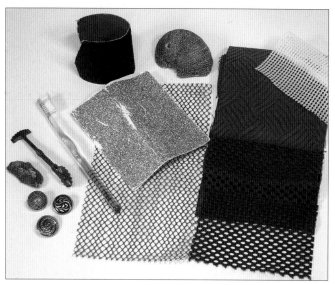

Various materials for creating texture.

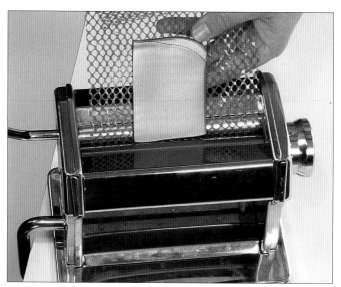

Adding texture to clay using the pasta maker and a texturing material.

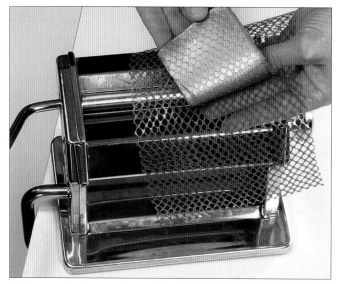

When you peel away the texture sheet from the clay, the texture can be seen on the clay surface.

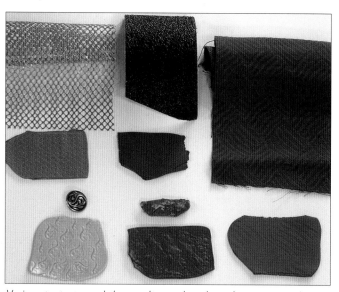

Various textures and the results produced on clay.

Mokumé Gané

Mokume gane is a Japanese term that means "wood grain metal." It's an ancient metalworking technique that involves layering different colored sheets of metal, fusing them, and pressing and pushing the metal to cause depressions, dimples, and bumps. The top is sanded and, because of the uneven layers, the various colors of metal show, resembling the grain of wood. The Tide Table project is a good example of how to incorporate mokume gane into a design.

Here's how to replicate this effect in polymer clay:

1. Stack into a block several thin sheets of different colored clays, alternating colors from layer to layer.

2. Make impressions in the clay, both from the top and the bottom of the block. (**photo 1**) To make the impressions, you can use bits of texture (like fabric or buttons), tools, lumps of clay – anything that makes an impression.

3. Flatten the block with your roller until it's about half an inch thick. (**photo 2**)

4. Bend a flexible blade into a curve and slice thin layers from the block. (**photo 3**)

5. Spread the slices on a sheet of base clay and roll them into the base. (**photo 4**)

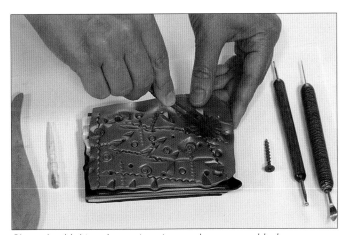

Photo 1 - Making depressions in a mokume gane block.

Photo 2 - Flattening a mokume gane block.

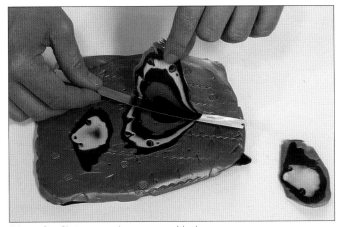

Photo 3 - Slicing a mokume gane block.

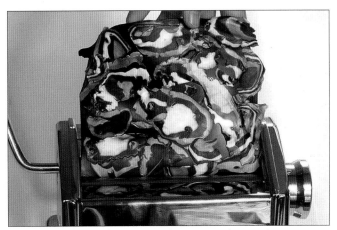

Photo 4 - Rolling mokume gane slices onto a base, using a pasta maker.

Mica Shift

Metallic and pearl polymer clays contain fine particles of mica, a mineral which looks like small, glittering scales. The mica particles are so fine that they're almost imperceptible, but you can manipulate and shift them in a number of ways to produce ghost-like images on the smooth surface of the clay. Light hitting the mica particles in a certain way produces the image, creating a three-dimensional effect. Polymer clay artist Pier Volkos is known as a pioneer in the technique of mica shifting. Margi Laurin, another polymer clay trailblazer, was the first to show me the potential of this technique.

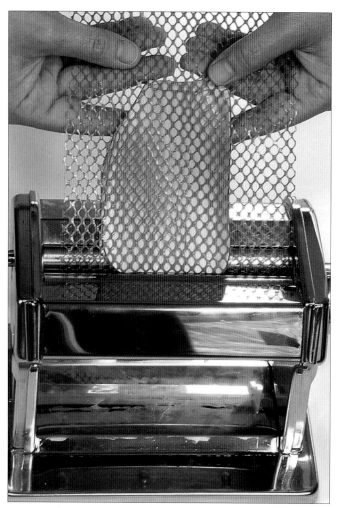

Photo 1 - Creating texture on the clay by rolling it with a piece of fabric.

Here's how:

1. Run the metallic or pearl clay through the pasta maker. Fold it and run it through repeatedly until it has an even color. (This lines up the mica particles so that they're all facing the same direction.)

2. Give the sheet a texture – one easy way is to run the sheet of clay with a piece of fabric through the pasta maker at the widest setting. Peel off the fabric. (**photo 1**)

3. Using your flexible blade, shave off the raised areas that were created by texturizing. (**photo 2**)

4. Run the clay sheet through the pasta maker again, but at a finer setting. Keep reducing the setting until you can no longer feel the texture on the clay. Magically, the texture can still be seen. (**photo 3**)

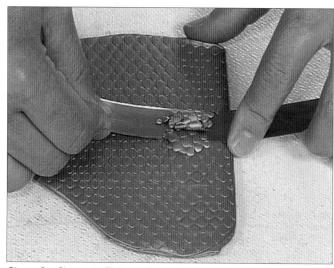

Photo 2 - Shaving off the surface of the texture.

How does it work?

When you shave off the surface of the texture, you shift the direction of the mica particles that touch your blade so you have particles facing two different directions. When the sheet is flattened again, light reflects off the particles, giving the impression the texture is still there. *Tip:* If, after baking, you sand and buff the surface, the ghost image will be even more obvious.

Photo 3 - A smooth sheet of clay with the texture still visible.

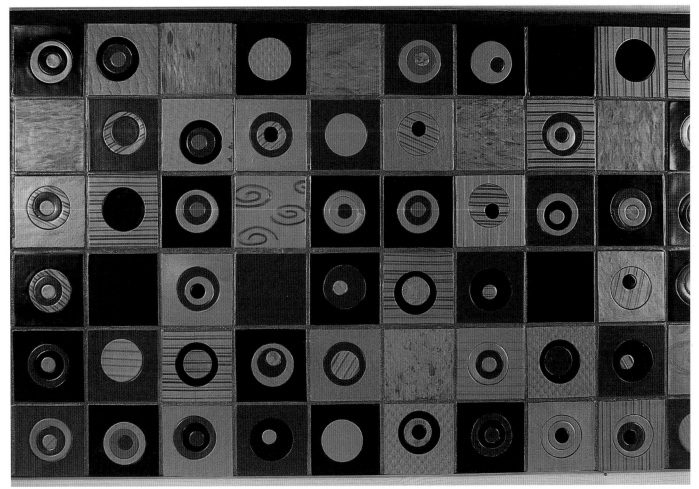

Tiles in the Klimt-Inspired Backsplash project showcase the mica shift technique.

GLOSSARY OF TERMS

The following terms are frequently used in the understanding and construction of mosaic designs. Whether you are a novice or experienced artist, you will find them helpful and interesting.

here is nothing in a caterpillar that tells you it's going to be a butterfly.

Buckminster Fuller

Buna cord: A smooth rubber cord used for pendants and necklaces, available in a variety of diameters, which is produced specifically for necklaces. It is available where jewelry findings are sold. A similar product can be found at automotive supply outlets.

Gradation: An imperceptible passing from one color or shade to another. In reference to polymer clay, gradation is commonly known as "Skinner blend," named for Judith Skinner who generously introduced her technique to countless people.

Leach: To cause a liquid to percolate through some material. If you find your clay too soft to work with, you can leach some of the plasticizer out of it by placing it between two sheets of white paper and weighing it down with a couple of heavy books. After a couple of hours the paper will have an oily residue on it. Change the paper and repeat the process until your clay reaches a workable consistency.

Liquid polymer clay: A liquid form of polymer clay, available in translucent or tinted, with many uses: grout, transfer medium, glue (once baked), glaze, and paint (if tinted). The translucent version can be mixed with oil paints to give it color and/or with polymer clay or inclusions to give it more body or texture.

Mica: A mineral that looks like small glittering scales.

Millefiori: A kind of ornamental glass made by fusing together a number of glass rods of different sizes and colors and cutting the fused glass into sections. This technique has been adapted successfully to polymer clay. It is also known as canework.

Mokume Gane: A Japanese metalworking term meaning "wood grain metal."

Opus tessellatum: A Latin term meaning inlaid in a regular pattern of small blocks.

Opus vermiculatum: A Latin term meaning inlaid in a pattern resembling the sinuous movements (tracks) of worms.

Pique assiette: In French, this term refers to a scrounger. In English, it refers to the method of using various found objects including broken plates (assiettes) and tiles to form a mosaic.

DESIGN CONSIDERATIONS

Leaving the most obvious question aside, that of subject matter, I'd like to look at several other important decisions when it comes to designing mosaics – color, directional flow of the tesserae, and size of the tesserae.

T The best way to have a good idea is to have lots of ideas.

Linus Pauling

■ Color

Bold, contrasting colors in your tesserae choices will give your mosaic energy and impact. Choosing a background color that contrasts greatly with the central design or figure causes the figure to stand out (e.g., black on white or yellow on blue). Conversely, a background color that relates closely to the central design (e.g., yellow on orange or blue on purple) will result in a more subdued piece.

The color of your grout is another consideration. If you want the distinction from one tesserae to the next to be obvious, choose a contrasting color – it will give a lively feel to your piece. If you want the fact that it's a mosaic to be less obvious, use grout that matches the tesserae. For another effect, try changing grout colors from one area of the mosaic to another.

■ Flow

Directional flow of the background tesserae also affects how your central design element stands out. If your background tesserae are regular shapes (squares, rectangles, triangles) and are arranged in rows or regular patterns then the central image will appear to be floating on the surface or above the background. (This method is called *opus tessellatum.*) On the other hand, background tesserae (in either regular or irregular shapes) arranged to follow the contour of the central image will result in the image appearing to be on the same level as the background. (This method is called *opus vermiculatum.*)

■ Size

When considering what size tesserae to use, keep in mind that the smaller the tesserae, the more intricate the detail you can achieve. Balance that with the knowledge it takes more time to fill an area with smaller tesserae, so it will take more time to complete the mosaic.

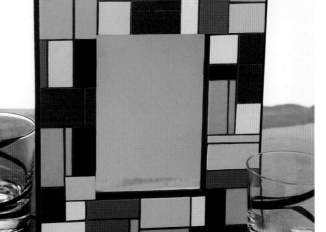

SAMPLE PROJECT

Now that you're getting familiar with the basic techniques as well as some of the more sophisticated processes, let's follow a project, step by step.

Key Holder

Hang this key holder mosaic on a nail or picture hanger hook on the wall and use it. Now you never need to ask if anyone's seen your keys!

SUPPLIES

Polymer Clay Sheets:

Each sheet is 1/16" (1.6 mm) thick (#4 setting on pasta maker).

Black, 2" x 2" and 6" x 2"

Dark gray, 5-1/2" x 1-1/2"

Lime green, 2-1/2" x 2"

Yellow, 2-1/2" x 1-1/2"

Metallic purple, 2-1/2" x 1-1/2"

Red, 2-1/2" x 1-1/2"

Metallic avocado green, 2-1/2" x 1-1/2"

Dark orange, 2-1/2" x 1-1/2"

4 different shades of blue, each 4" x 2"

White, 6" x 2"

Other Supplies:

Wood base, 10" x 6-1/4", 3/4" thick

4 keys

1 round pearl button, 1" diameter

4 cup hooks, 1/2"

2 screw eyes, 1/4"

11" picture hanging wire

Polyvinyl acetate (PVA) glue

White, premixed, siliconized tile grout, 4 Tbsp.

Acrylic craft paint - Blue

Equipment & Tools:

Scraps of stiff cardboard

1/4" cardboard cutting guide

Paper

Cardstock

Carbon paper

Ruler

Pencil

Small paper drinking cup (for grout)

Scraps of wax paper for glue

Sponge

Bucket of water

Wet/dry sandpaper, 280, 400, 600, 800, 1000 grits

Lint-free cloth

Liquid polymer protectant

Glass cutting board

Pasta maker and/or acrylic roller

Long-blade craft knife *or* polymer clay slicing blade

Fine-tip craft knife

Rubber-tipped sculpting tool

Small palette knife (for mixing paint with grout)

Synthetic bristle paint brush

Hobby or hand drill and drill bits (approx. same diameter as cup hook and screw eye shanks)

Optional: Fine-tip permanent marker

Instructions follow on page 46

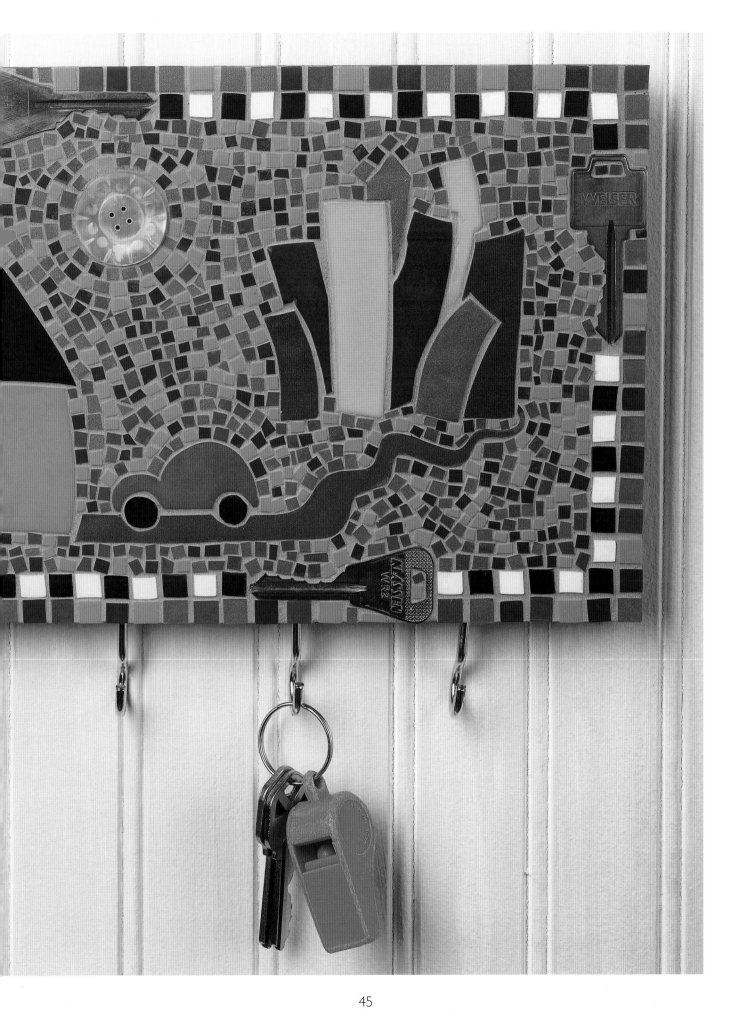

INSTRUCTIONS

■ Cut the Tesserae

Note: For this project and many others, you will make more tesserae than you need. Remember it's always good to have too many than too few. Eventually your stash of leftover tesserae yield enough to do a whole project.

1. Following the instructions in the Basic Techniques section, make cardstock templates from the patterns on page 56.

2. Place all the sheets of clay on the glass cutting board. Place the templates on the clay as follows:
 Figs. A and E on the 2" x 2" sheet of black
 Fig. B on the sheet of lime green
 Fig. C on the sheet of dark orange
 Fig. D on the sheet of dark gray
 Fig. F (two templates) on the sheet of metallic purple
 Fig. G (two templates) on the sheet of red
 Fig. H (two templates) on the sheet of yellow
 Fig. I (two templates) on the sheet of metallic avocado green

3. Use the knife to cut around the templates. Peel away the excess clay. **(photo 1)**

4. Place the 1/4" cardboard guide on one of the blue sheets of clay. Using it as a guide, drag your blade along the edge to cut the sheet into 1/4" strips. **(photo 2)** Leave the strips on the glass. If they moved while you were cutting them, line them up evenly again.

5. Place the guide at a right angle to the cuts you just made and cut again. Move the guide along the length of the strips, lining the edge with the previous cut mark so that each cut you make now produces a number of 1/4" x 1/4" tesserae.

6. Repeat steps 4 and 5 with the remaining blue sheets of clay. as well as the 6" x 2" sheets of black and white polymer clay.

 I paint with shapes.

Alexander Calder

Photo 1 - Cutting clay using a template.

Photo 2 - Cutting strips of clay with a cardboard guide.

Photo 3 - Cutting the strips into tesserae with a cardboard guide.

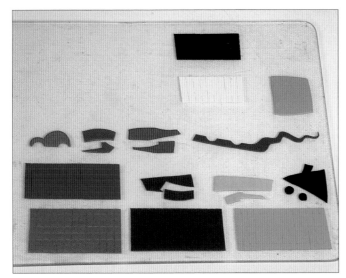
Photo 4 - Clay is cut and ready to bake.

■ Bake the Clay

Bake the glass sheet with all the tesserae at 275 degrees F. for 45 minutes. (**photo 4**) Allow to cool in oven.

■ Transfer the Design

1. Photocopy the design. Place a piece of carbon paper, ink side down, on the wood base. Place the photocopy of the design face up on the carbon paper. Using a dull pencil, trace over the lines of the design. (**photo 5**)

2. Check to see that the design is transferring. (**photo 6**)

Be careful not to shift the papers during this process. When the entire design is transferred, remove the papers. *Option:* To darken the carbon lines, trace over them with a fine-tip permanent marker.

■ Glue the Larger Tesserae

1. On your work surface, lay out all the pieces you'll be using to create the mosaic design. Squeeze a small puddle of glue on a piece of wax paper.

2. Use the rubber-tipped sculpting tool to "butter" (apply glue) the back of a tessera (**photo 7**).

Continued on next page

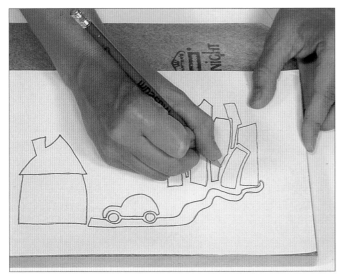
Photo 5 - Transferring the pattern to the wood base.

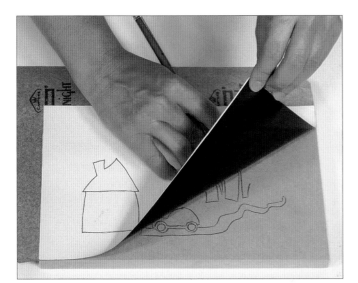
Photo 6 - Checking the transfer.

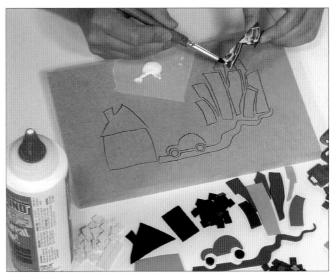
Photo 7 - Applying glue to the back of the first tessera to be placed.

continued from page 47

3. Set the piece in place, following the transferred pattern and the project photo as guides. (**photo 8**)

4. Working one large piece at a time, continue gluing and placing all the large pieces (the buildings, the car, and the road).

5. Apply glue to one side of one of the keys (**photo 9**) and place it on the right border, 1" from the top. (**photo 10**)

6. Apply glue to another key and place it on the left border, 1" from the bottom.

7. Apply glue to the third key and place it 2-3/8" from the left edge along the top.

8. Apply glue to the remaining key and place it on the bottom, 2-3/8" from the right edge.

9. Butter the back of the button with glue and place it firmly on the base, using the photo as a guide for placement.

■ Glue the Border

Note: With smaller tesserae, it's often easier to spread the glue on the base rather than on each tessera. Do what works best for you – either butter the back of each tessera or spread a line of glue along the border of the base. *Tip:* If you're spreading the glue on the base, don't do the whole border at once because the glue will dry before you have time to get all the tesserae on it.

1. If the tesserae are still stuck together, snap them apart at the cut marks.

2. Glue down the blue tesserae, alternating randomly from one color to another, all around the edge of the base, allowing space for grout. As you come to a key you may need to cut a tessera to fit around it –

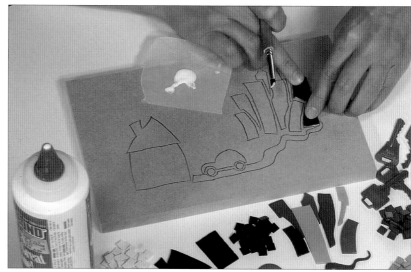
Photo 8 - Placing the first piece.

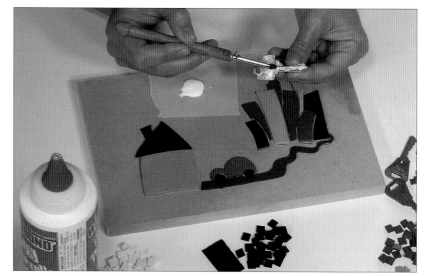
Photo 9 - Applying glue to the back of a key.

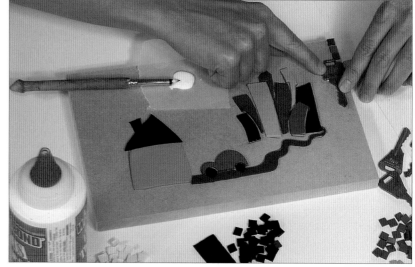
Photo 10 - Placing the key.

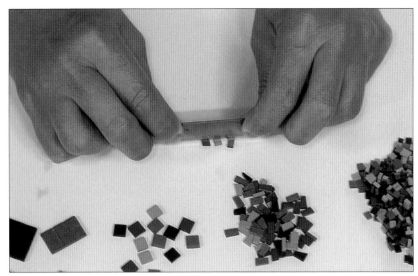

Photo 11 - Cutting baked tesserae.

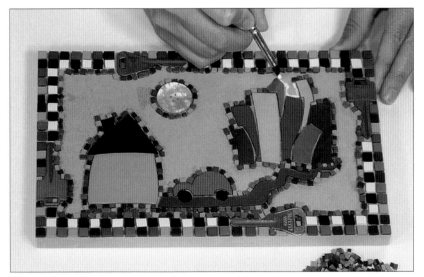

Photo 12 - Spreading glue in a thin line around larger tesserae.

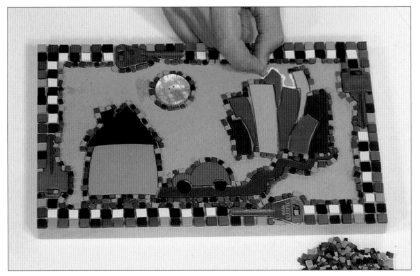

Photo 13 - Placing smaller tesserae on applied glue.

make straight cuts in a baked tessera by pressing down firmly on the tessera with a long craft blade or polymer clay blade. The tessera will cut with a snap.

3. Now glue another row of the border inside the first, alternating black and white tesserae.

■ Glue the Background

Note: The background consists of the remaining 1/4" blue tesserae cut into smaller, randomly shaped pieces.

1. Make straight cuts by pressing down firmly on the tessera with a long craft blade or polymer clay blade. (**photo 11**) The tessera will cut with a snap.

2. Begin the background with a line of glue around a section inside the border. Set the smaller, randomly shaped blue tesserae on the glue, continuing for the whole inside perimeter. Don't forget to leave space for grout.

3. Next use the same technique to set tesserae around the larger tesserae and the button. (**photo 12**)

4. Continue setting the smaller tesserae to fill in all the remaining background. Let cure for 24 hours. (**photo 13**)

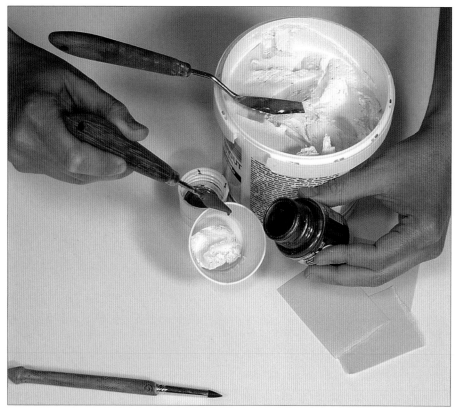

Photo 14 - Tinting the grout with acrylic paint.

continued from page 49

■ Grout the Design

1. Place a few tablespoons of grout in a paper cup. Tint grout by adding a few dabs of blue acrylic paint. Mix with a palette knife. (**photo 14**)

2. Use the palette knife to place some grout on the mosaic. (**photo 15**)

3. Cut a scrap of cardboard 1-1/2" x 3". Use the cardboard to spread the grout across the tesserae, working back and forth, pushing the grout into the spaces between the tiles. (**photo 16**) Hold the cardboard at about a 30 degree angle and drag diagonally.

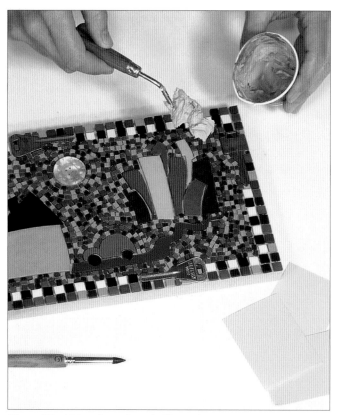

Photo 15 - Using the palette knife to place grout.

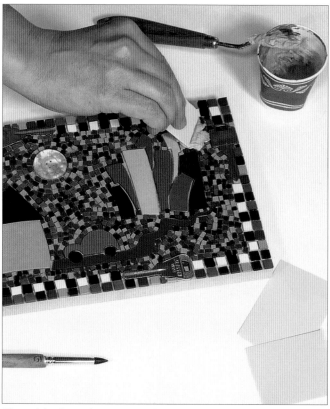

Photo 16 - Spreading grout with a piece of cardboard.

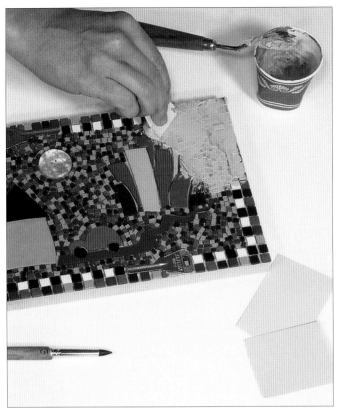

Photo 17 - Continue to spread grout.

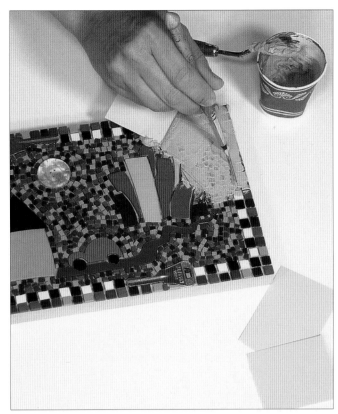

Photo 18 - Using the sculpting tool to remove grout from a key.

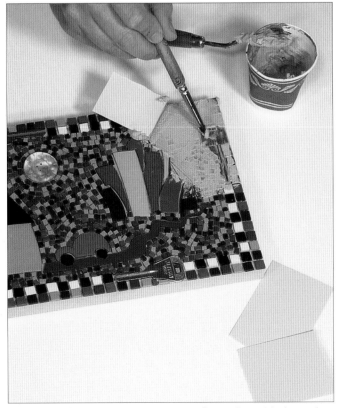

Photo 19 - Continuing to remove grout from a key with the sculpting tool.

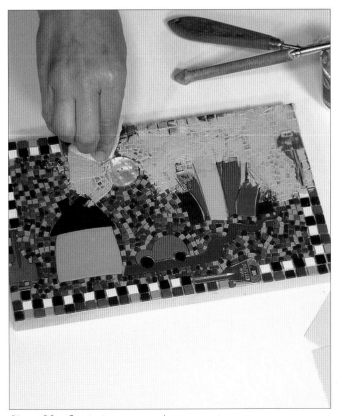

Photo 20 - Continuing to spread more grout.

continued from page 50

4. Continue to spread the grout, using the cardboard scrap. (**photo 17**) Use the rubber-tipped sculpting tool to remove excess grout from the key. (**photos 18, 19**)

5. Continue spreading grout, working your way across the top of the mosaic. (**photo 20**)

6. Use the rubber-tipped sculpting tool to remove excess grout around and on top of the button. (**photo 21**)

7. Continue to spread grout until all spaces between the tesserae are filled. Use a clean piece of cardboard and/or the rubber-tipped sculpting tool to lightly remove the large amounts of excess grout from the surface. (**photo 22**) Wait 30 minutes.

8. Wipe the surface with a barely damp sponge, rinsing the sponge frequently in a bucket of water. (**photo 23**) Be careful not to apply too much pressure – that could pull out some of the grout from between the tesserae.

9. Do a final pass with a dry, lint-free cloth. Allow 24 hours to cure.

■ Sand and Buff

1. Dip a piece of 280 grit wet/dry sandpaper in a bucket of water. Sand the entire surface of the mosaic, using a circular motion. (**photo 24**) Rinse the sandpaper frequently. Sanding removes excess grout that has dried on the surface of your tesserae.

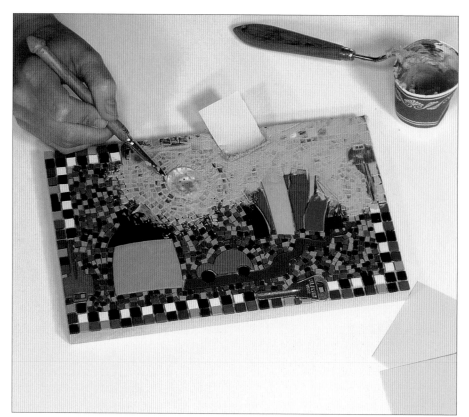

Photo 21 - Removing grout from around the button.

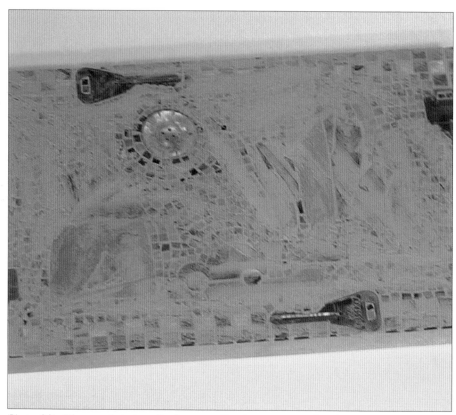

Photo 22 - The mosaic is completely grouted, and excess grout has been removed.

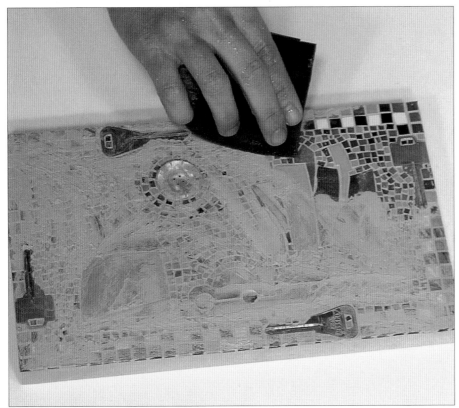

2. Sand again, first with 400 grit, then with 600, 800, and 1000 grit sandpapers. Use a fairly light touch as you sand and wipe off excess water as necessary.

3. Wash down the mosaic with a cloth and clean water. Buff dry with a clean cloth. (**photo 25**)

Photo 23 - Wiping the surface with a damp sponge.

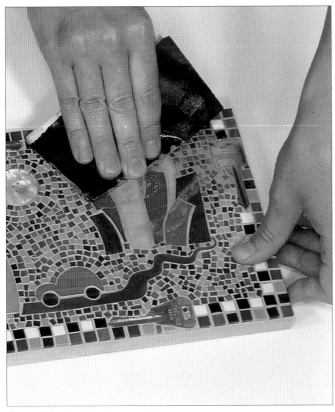

Photo 24 - Sanding the mosaic.

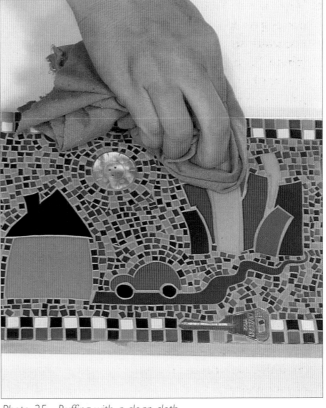

Photo 25 - Buffing with a clean cloth.

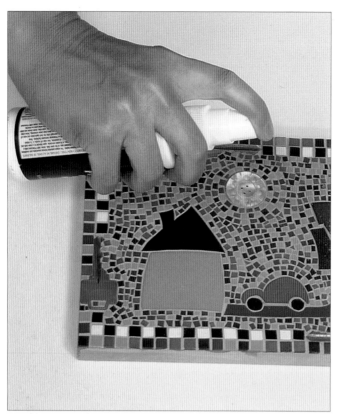

Photo 26 - *Spraying the surface with liquid polymer protectant.*

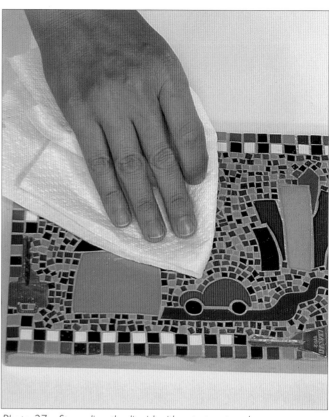

Photo 27 - *Spreading the liquid with a paper towel.*

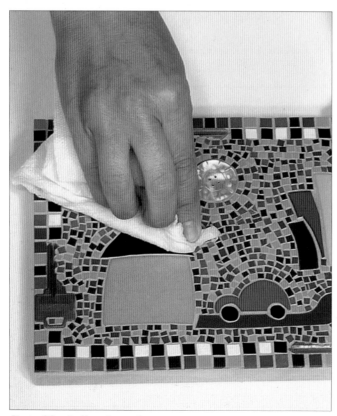

Photo 28 - *Buffing the surface.*

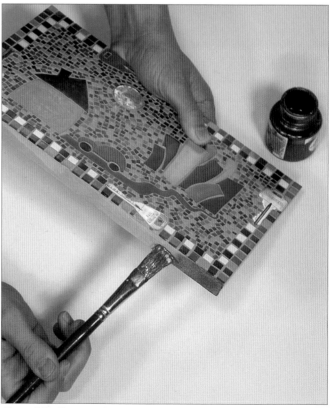

Photo 29 - *Painting the edges with acrylic paint.*

■ Finish

1. Spray a mist of liquid polymer protectant on the mosaic surface. (**photo 26**)

2. Spread the polymer protectant over the entire surface with a paper towel. (**photo 27**) Allow to dry for half an hour. Spray again and allow to dry for another half hour.

3. Buff the surface, removing any excess. (**photo 28**)

4. Paint the edges of the wood base with blue acrylic paint. (**photo 29**) Allow to dry.

5. Use a hobby or hand drill with the appropriate-size bit to make four pilot holes at 2" intervals in the bottom of the base. (The bit should be about the same size as the threaded part of the cup hook.) (**photo 30**)

6. Screw in the four cup hooks. (**photo 31**) *Tip:* If your pilot hole seems too large, put a dab of glue on the hole. The cup hook will drag the glue into the hole as it goes in.

7. Drill two pilot holes on the back of the base, spacing them 2" down from the top and 1" in from the side edges.

8. Install the screw eyes.

9. Thread the wire through the screw eyes (**photo 32**). Twist the ends of the wire to secure. (**photo 33**) ❏

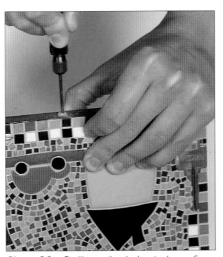
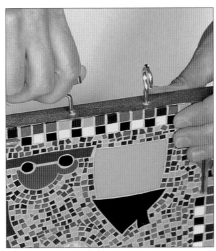

Photo 30 - Drilling pilot holes in base for hooks.

Photo 31 - Inserting the cup hooks.

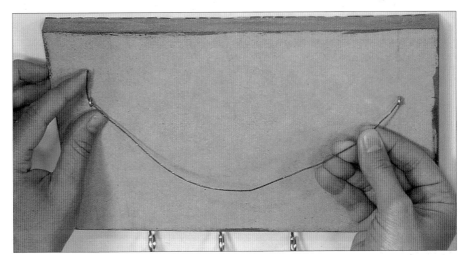

Photo 32 - Installing the picture wire.

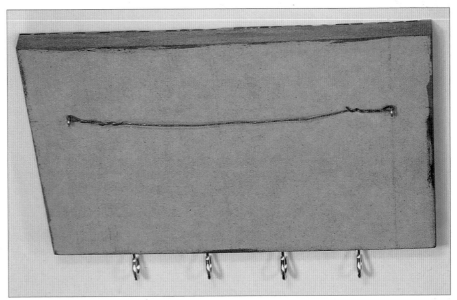

Photo 33 - The picture wire in place, ready for hanging.

Key Holder Patterns

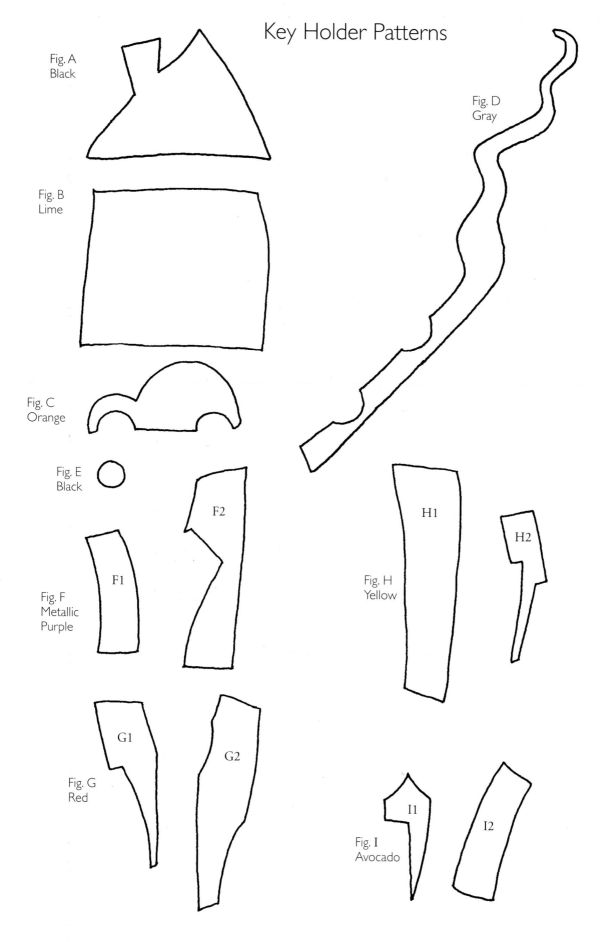

Fig. A
Black

Fig. B
Lime

Fig. C
Orange

Fig. D
Gray

Fig. E
Black

F2

F1

Fig. F
Metallic
Purple

H1

H2

Fig. H
Yellow

G1

G2

Fig. G
Red

I1

I2

Fig. I
Avocado

Fig. J

THE PROJECTS

Polymer clay can be used to decorate a variety of surfaces, including wood, plastic, metal, and glass. It can be used to create objects as small as a zipper pull or a refrigerator magnet, as large as a tabletop or door panel. This section of the book contains more than twenty projects using polymer clay.

Thank goodness I was never sent to school; it would have rubbed off some of the originality.

Beatrix Potter

Each project includes a list of supplies, tools and equipment needed, plus step-by-step instructions, photographs, and all the necessary patterns.

Some words of caution: Although polymer clay can look just like ancient mosaics of stone or modern ones of ceramic, there are some uses for which polymer clay is not suitable. Because polymer clay is not as durable as stone or ceramic, it is not a good choice for floor mosaics, cutting surfaces, or trivets. Polymer clay should never be used in containers or on surfaces that hold food – there is the potential for acids in foods to cause the plasticizers in the clay to leach out.

That said, there is still a wide range of applications for polymer clay tesserae as you will discover in the projects that follow.

Basic Equipment & Tools

See pages 14 and 15 for an explanation of the items you will need for each project.
Following is the list of the items you will need for each project as a reminder.
These are not listed with each project because they are needed for all projects.

- Glass Cutting Board
- Pasta Maker or Acrylic Roller
- Scraps of stiff cardboard (for applying grout)
- Paper

- Ruler
- Wet/dry sandpaper, 280, 400, 600, 800, 1000 grits
- Rubber-tipped sculpting tool
- Pencil

- Cotton swabs and sponges for cleanup of grout and liquid clay
- Cutting Tools: long blade craft knife or polymer clay slicing blade

- Palette knife
- Paint brush
- Lint-free cloth
- Paper cups

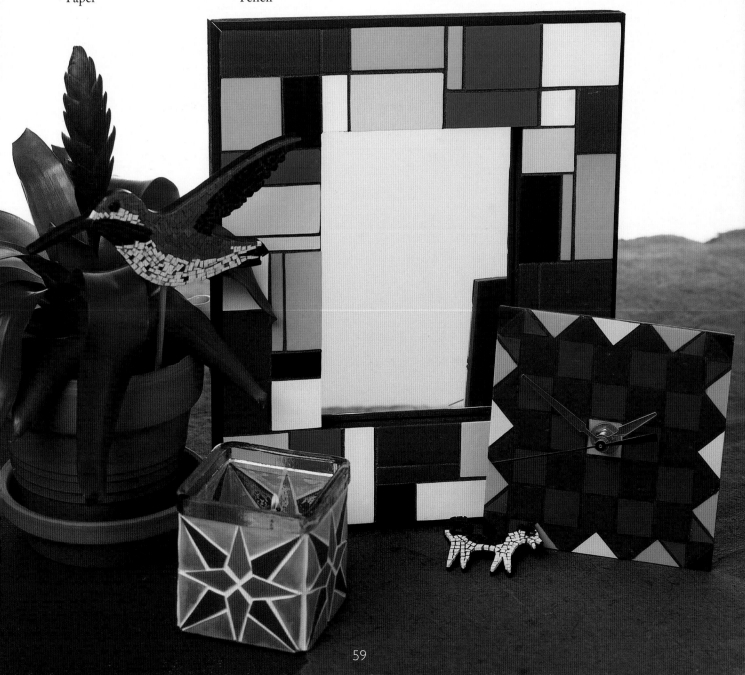

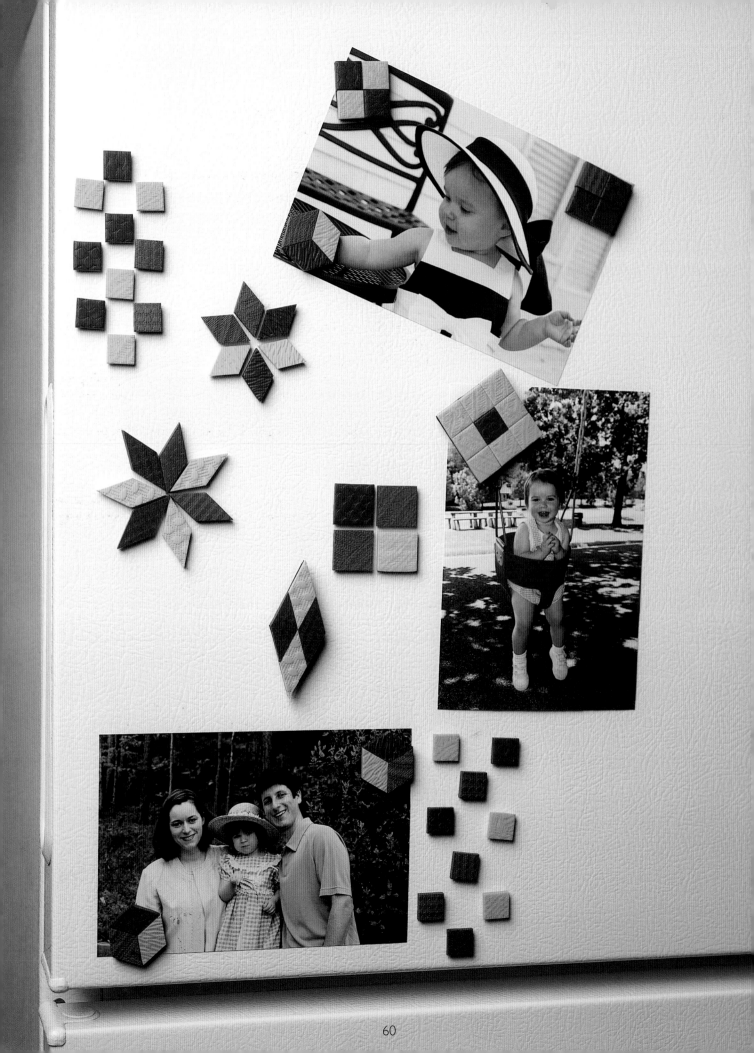

MOSAIC MAGNETS

This is a great first project. It allows you to practice several basic techniques and it leaves you with a valuable creative toolbox – various tesserae with which to practice designing geometric mosaics.

SUPPLIES

Polymer Clay:

Sheets of various colors, as little or as much as you like, 1/8" or 3.2 mm thick (#1 setting on pasta maker)

Optional: Smaller sheet of polymer clay to use as a base, 3/64" (1.2 mm) thick (#5 setting on pasta maker)

Other Supplies:

Magnets *or* magnet tape

Cyanoacrylate glue (if using magnets, not magnet tape)

Rubbing alcohol (if using magnets, not magnet tape)

Equipment & Tools:

In addition to those listed on page 59.

Cardboard cutting guides

Materials to create texture (see Beyond Basics section)

INSTRUCTIONS

Cut and Bake:

1. Following instructions in the Beyond Basics section, add texture to the various sheets of 1/8" thick clay.
2. Use templates made from the figures provided to cut diamonds.
3. Follow the instructions in the Basic Techniques section for using graph paper or grid patterns and for using cardboard cutting guides to cut squares ranging from 3/4" to 1/2".
4. Bake on glass cutting board at 275 degrees F. for 45 minutes. Allow to cool in oven.

Attach Magnets:

You have two options – you can either attach magnets directly to the backs of individual tesserae or arrange the tesserae into little mosaics and turn them into larger magnets. (Of course, you can do both.)

▧ Individual tesserae magnets

If you're using magnetic tape:
1. Cut a piece to fit the back of each tessera.
2. Peel off the paper.
3. Stick the magnet tape firmly to the clay.

If you're using a regular magnet:
1. Use a sharp blade to scuff the clay where the magnet will be placed.
2. Wipe the magnet with rubbing alcohol to remove any oils.
3. Put a drop of glue on the magnet and press firmly to the clay.

▧ Mosaic magnets

1. Play with the arrangement of the tesserae until you have several mosaic patterns you like.
2. Place the sheet of 3/64" thick clay on the glass.
3. Assemble the mosaics on the base clay, pressing them firmly to the base. **Don't** leave space for grout; place each tessera flush with the surrounding ones. Cut away the excess clay from around the mosaics.
4. Bake at 275 for half an hour. Leave in the oven to cool.
5. Attach magnets as directed above. ❏

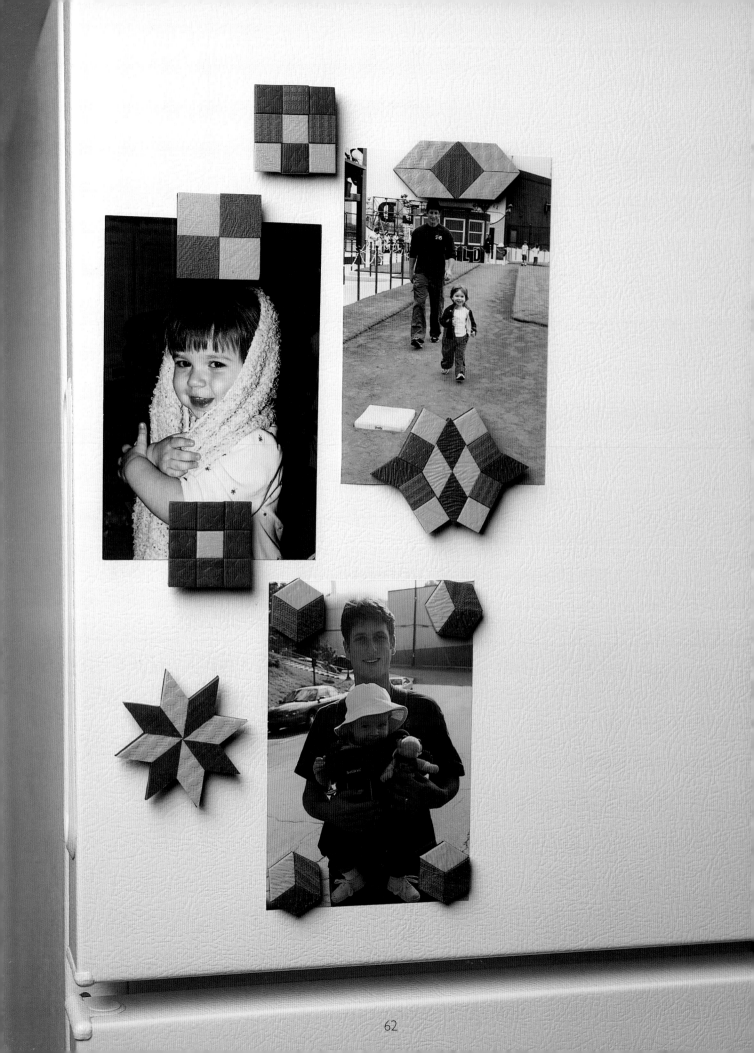

Templates

Fig. A
45-degree diamonds

Fig. B
60-degree diamonds

CHEVRON EARRINGS

A simple project – but these earrings can turn a shy person into the life of the party.
Try them in your favorite colors.

SUPPLIES

Polymer Clay Sheets:

Each sheet is about 1/16" (1.6 mm) thick (#4 setting on pasta maker).

Turquoise, 2" x 2"

Metallic purple, 1-1/2" x 1-1/2"

Silver, 1-1/2" x 1-1/2"

Other Supplies:

Liquid polymer clay, 1/2 tsp.

2 surgical steel shepherd hooks

2 silver jump rings, 1/4" inside diameter

Oil paint - turquoise

Liquid polymer protectant

Equipment & Tools:

In addition to those listed on page 59.

Cardstock

Cardboard cutting guides

Material to create texture (see the Beyond Basics section)

Smooth ceramic tile

Rubbing alcohol (for cleaning liquid clay brush)

1/16" drill bit

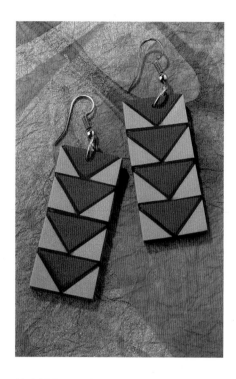

INSTRUCTIONS

Cut and Bake:

1. Add texture to one side of turquoise clay. (See the Beyond Basics section.) Place it, textured side down, on a sheet of white paper on the glass cutting board.
2. Make a cardstock template, 1-9/16" x 3/4". Following the directions in the Basic Techniques section for using templates, cut out the base from the textured sheet of turquoise clay.
3. Place the purple clay on a sheet of white paper. Use cardboard cutting guides and knife to cut four tesserae, 1/2" x 1/2". Cut these pieces diagonally in half.
4. Place the silver clay on a sheet of white paper. Use cardboard cutting guides and the knife to cut four

tesserae, 1/2" x 1/2". Cut these pieces diagonally in quarters.
5. Using the photo as a guide, place the tesserae on the smooth side of the turquoise bases, leaving space for grout. Place a sheet of paper on top and rub lightly through the paper to ensure good contact between the layers of clay. Leave the paper on the clay.
6. Put the paper and mosaics on the glass cutting board. Place a smooth ceramic tile on top to ensure that the clay remains flat during baking and cooling.
7. Bake at 275 degrees F. for one hour. Allow to cool in the oven. Remove tile and paper from top.
8. Mix liquid clay with a drop of turquoise oil paint to make a grout. Apply grout according to the instructions in the Basic Techniques section.
9. Bake at 275 degrees F. for 20 minutes. Remove from oven. Place a sheet of paper and ceramic tile on top to ensure that the clay remains flat while it cools.

Finish:

1. Holding the drill bit in your fingers, twist it through each earring, approximately 1/8" from the top.
2. Sand the mosaic, following the directions for sanding in the Basic Techniques section.
3. Apply two coats polymer protectant. Allow to dry a half hour between coats. Let second coat dry for half an hour.
4. Attach jump rings and shepherd hooks. ❏

GLEAMING PENDANT

A touch of metallic sheen in this mosaic pendant turns an easy project into a special piece of jewelry.

SUPPLIES

Polymer Clay Sheets:

About 1/8" (3.2 mm) thick (#1 setting on pasta maker)

Black, 4" x 1-1/2"

About 1/16" (1.6 mm) thick (#4 setting on pasta maker)

Black, 1-1/2" x 1"

Gold, 1-3/4" x 1/2"

Metallic avocado green, 1-3/4" x 1/2"

Other Supplies:

Liquid polymer clay, 1 tsp.

2 mm (5/64") buna cord, 28" long

Cyanoacrylate glue

Oil paint - black

Liquid polymer protectant

Equipment & Tools:

In addition to those listed on page 59.

1/4" cardboard cutting guides

Cardstock

Rubbing alcohol (for cleaning liquid clay brush)

Material for creating texture on clay

INSTRUCTIONS

Cut:

1. Add texture to one side of the 4" x 1-1/2" sheet of black clay (see the Beyond Basics section). Place it, textured side down, on the glass cutting board.

2. Using Fig. A, make a template (see the Basic Techniques section). Use

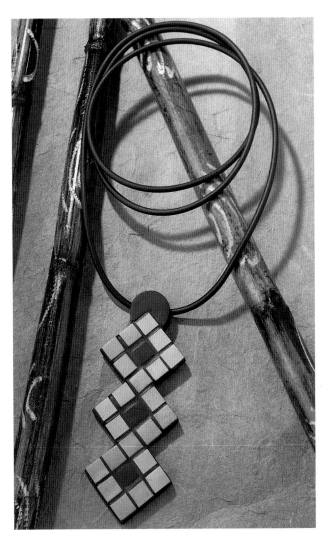

it and the knife to cut out the base from the textured sheet of black clay. Use a rubber-tipped sculpting tool or your finger to smooth the cut edges. Set aside the excess clay to use later.

3. Flip over the base so the textured side is up. Press the buna cord on the base to create a channel about half the thickness of the cord. Remove the cord. Flip over the base again, textured side down.

4. Place the remaining sheets of clay on the glass.

5. Use the cardboard cutting guides and the knife to cut the gold and metallic avocado green sheets into 1/4" tesserae, 11 of each color.

6. Cut three black 1/4" tesserae.

7. Make a template from Fig. B. Use it to cut one black tessera. (See the Basic Techniques section.)

Bake:

1. Bake the base and the tessera at 275 degrees F. for 45 minutes. Allow to cool in oven.

2. Spread a thin layer of liquid clay over the smooth front of the pendant base.

3. Using the project photo as a guide for the design, place the tesserae on the liquid clay, leaving space for grout.

4. Bake at 275 degrees F. for 15 minutes. Remove from oven and allow to cool.

5. To make grout, mix about a 1/2 tsp. liquid clay with a tiny dab of black oil paint. Follow the instructions in the Basic Techniques section for grouting with liquid clay.

6. Bake at 275 degrees F. for 20 minutes. Allow to cool.

Assemble and Bake:

1. Use glue to join the ends of the buna cord.

2. Place the pendant, mosaic side down, on the glass. Put a drop of glue in the channel and press the joined, glued section of buna cord into the channel.

Continued on next page

continued from page 65

3. Make a template from Fig. C. Use it to cut out a piece of the #1 thickness black textured clay that was left over from step 2 in the "Cut" section above.
4. Place this, textured side up, over the channel and the buna cord. Press carefully to join it to the pendant.
5. Bake at 275 degrees F. for 45 minutes. Remove from oven. Weigh down with a book so that it remains flat as it cools.

Finish:
1. Sand the mosaic, following the directions for sanding in the Basic Techniques section.
2. Finish with two coats of polymer protectant. Let dry a half hour between coats. Let second coat dry a half hour. ❏

Patterns

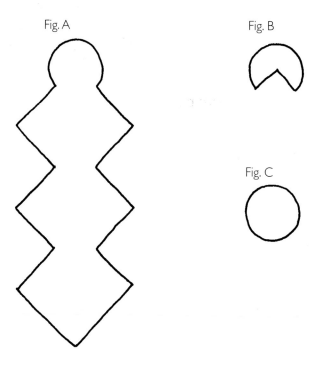

Fig. A

Fig. B

Fig. C

Votive Candle Holder
Patterns

Fig. A

Fig. B

Fig. C

VOTIVE CANDLE HOLDER

Let there be light, and let it shine through the translucent mosaic
(made from translucent polymer clay) that covers this square candle holder.
The effect is subtle and mysterious.

SUPPLIES

Polymer Clay Sheets:

*Each sheet is very thin (#7 setting on
pasta maker).*

Translucent purple, 5" x 3"

Translucent red, 5" x 3"

Translucent green, 10" x 3"

Other Supplies:

In addition to those listed on page 59.

Square glass votive holder, 2-7/8"
cube

Cyanoacrylate glue

Vinyl adhesive caulk

INSTRUCTIONS

Cut and Bake:

1. Place the sheets of clay on the glass
cutting board.
2. Use the patterns to make templates
(see Basic Techniques section) to
cut out the tesserae:
Fig. A - 32 green
Fig. B - 16 purple
Fig. C - 16 red
3. Bake at 275 degrees F. for a half
hour. Remove from oven and allow
to cool.

Assemble:

1. Working on one side at a time and

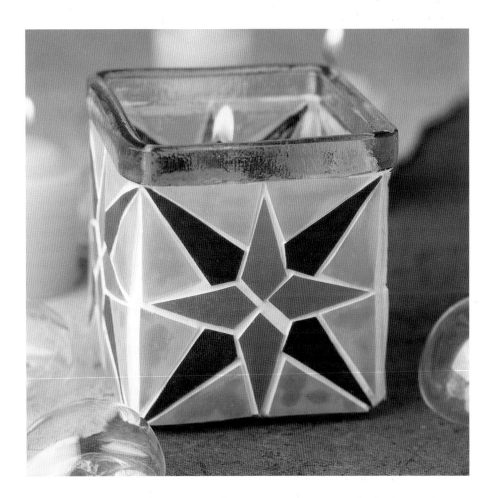

using the project photo as a guide,
place the tesserae on the candle
holder.
2. When the placement pleases you,
remove them one at a time, apply a
small amount of glue to the back,
and press firmly into position.

Continue until all four sides are
complete.
3. To grout, follow the instructions in
the Basic Techniques section for
grouting with vinyl adhesive caulk.
❏

CD CLOCK

Bright colors with the look of tie-dye – funky as a teenager's dream! Start with an old CD and take off from there. Shades of reggae? The Ethiopian flag? Anything goes! Rather than cutting the tesserae and assembling the mosaic, this piece is carved after baking, then grout is added.

SUPPLIES

Polymer Clay Sheets:

*Each sheet should be about 1/8"
(3.2 mm) thick (#1 setting on pasta maker).*

Yellow, one sheet, 1" x 6"; two sheets, each 6" x 3/4"

Red, two sheets, each 6" x 3/8"

Green, two sheets, each 6" x 1/2"

Other Supplies:

Pinch of black polymer clay

Pinch of white polymer clay

Liquid polymer clay

Compact disc

Clock kit

Oil paint - black

Polyvinyl adhesive glue

Cyanoacrylate glue

Liquid polymer protectant

Permanent marker

Equipment & Tools:

In addition to those listed on page 59.

Rubbing alcohol (for cleaning liquid clay brush)

Needle tool

V-gouge linoleum cutter

INSTRUCTIONS

Prepare the Clay:

1. Spread a thin layer of glue on one side of the CD. Allow to dry a half hour.
2. Butt your sheets of clay together to form one sheet, using Fig. A as a guide.
3. Run the sheet through the pasta maker at the #3 setting.
4. Fold the sheet in half (see Fig. B). Run through the pasta maker at #3 setting, folded end first. (This reduces the risk of trapping air in the fold of the clay.) Repeat about 30 times or until you're happy with the pattern.
5. Place the sheet of clay, best side down, on a sheet of white paper.
6. Place the CD, glue side down, on the clay, centering the hole in the CD with the yellow section in the middle of the clay sheet.
7. Place a sheet of paper on the CD so the clay and CD are sandwiched between two sheets of paper. Flip over the sandwich so the CD is on the bottom. Rub the clay through the paper to ensure that the clay adheres uniformly to the CD.
8. Flip the sandwich again so the clay is on the bottom.
9. Remove the paper from the CD. Cut around the CD with a knife. Remove the excess clay.
10. Use the fine-tipped craft knife to make a hole in the clay through the center of the CD hole. (This is for the clock works.) Put the sheet of paper back on the CD side.
11. Place the CD and clay, CD side down, on the glass cutting board. Remove the paper from the clay.
12. Make 8 little black balls and 4 little white balls of clay. Flatten them and place on a sheet of paper on the glass cutting board.

Bake:

1. Bake the flattened balls and the clay/CD combination (the clock face) at 275 degrees F. for 30 minutes. Remove from oven.

Continued on page 71

Time flies like the wind. Fruit flies like bananas.

Groucho Marx

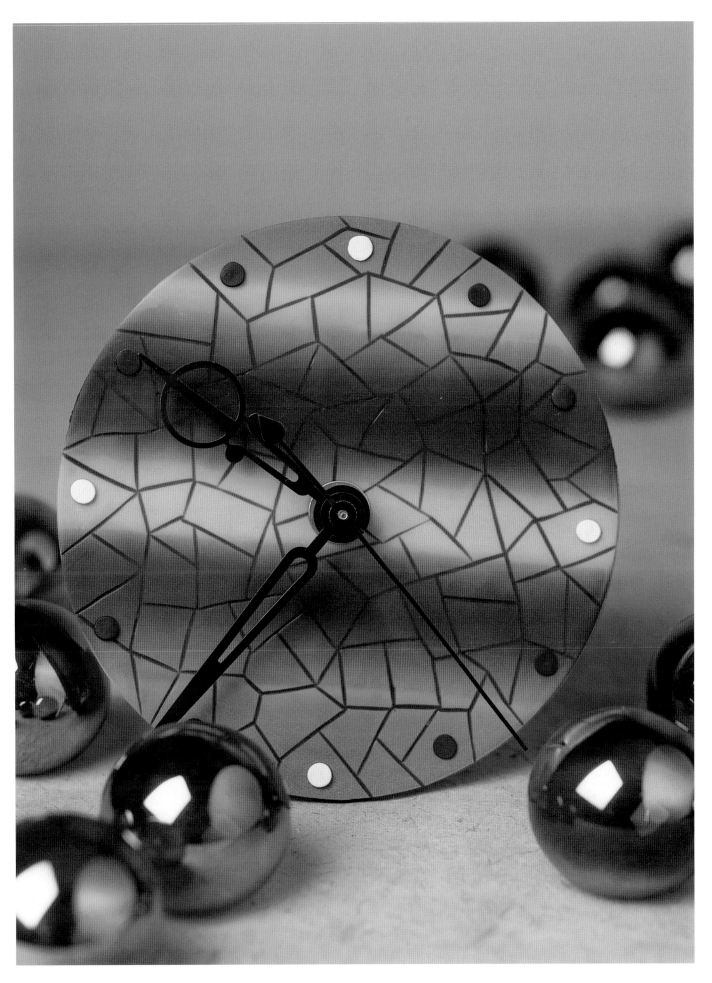

Fig. A - How to place the colors for the clay sheet

Green Yellow Red Yellow Red Yellow Green

Fold here

Fig. B - How to Fold the clay sheet

continued from page 68

2. Place a sheet of paper on top of the clock face. Weigh it down with a book so it remains flat as it cools.

Mark and Carve:

1. Photocopy pattern for clock below and cut it out. Position it on the baked clay clock face.
2. Use the needle tool to poke through the 12 number positions, marking the clay underneath. Remove the paper. Go over the marks with a permanent marker.

3. Using a v-gouge linoleum cutter, randomly carve grout lines all over the clay surface. Don't go too deep – you just want to create a channel to hold the liquid clay. Don't carve any grout lines through the number marks.

Grout:

1. To make the grout, mix liquid clay with a dab of black oil paint.
2. Apply grout to fill carved lines and bake according to the instructions in the Basic Techniques section for grouting with liquid clay.

Finish:

1. Sand according to the instructions in the Basic Techniques section.
2. Use cyanoacrylate glue to attach the little circles of clay at the hour marks, using the photo as a guide for color placement.
3. Apply two coats polymer protectant to mosaic surface. Allow to dry a half hour between coats. Let second coat dry for half an hour.
4. Install the clock kit on the mosaic face.

Pattern for Clock Face

DASHING DOG PINS

Wear one on a sweater! Pin one on a hat!
This mosaic pooch adds a bit of whimsy to your wardrobe.
This supplies list is for the black and white dog; the other one is made the same way using
tesserae left over from other projects. Have fun experimenting with different colors.

SUPPLIES

Polymer Clay Sheets:

Black

2-1/2" x 2", 1/8" (3.2 mm) thick
 (#1 setting on pasta maker)

2" x 1/2", 1/16" (1.6 mm) thick
 (#4 setting on pasta maker)

3/4" x 3/8", 3/64" (1.2 mm) thick
 (#5 setting on pasta maker)

White

3" x 1/2", 1/16" (1.6 mm) thick
 (#4 setting on pasta maker)

Other Supplies:

Liquid polymer clay, 1 tsp.

Silver bead, 3/32" (2.4 mm)

Bar pin, 1-1/4"

Cyanoacrylate glue

Oil paint - black

Liquid polymer protectant

Equipment & Tools:

In addition to those listed on page 59.

1/4" cardboard cutting guides

Rubbing alcohol (for cleaning liquid
 clay brush)

Needle tool

Materials for adding texture (see the
 Beyond Basics section)

INSTRUCTIONS

Cut and Bake:

1. Add texture to one side of the 2-1/2" x 2" sheet of black clay (see the Beyond Basics section). Place it, textured side down, on the glass cutting board.
2. Make a template from the pattern (see Basic Techniques section) and use it to cut out the base from the textured sheet of black clay. Use a rubber-tipped sculpting tool or your finger to smooth the cut edges.
3. Place the 1/16" thick sheets of black and white clay on the glass cutting board. Use cardboard cutting guides and a knife to cut the sheets into 1/4" strips. (See the Basic Techniques section for information about cutting tesserae.)
4. Bake the base and the strips at 275 degrees F. for 45 minutes. Allow to cool in oven.

Create the Mosaic:

1. With glue, attach the bead to the smooth side of the dog base, using the pattern as a guide.
2. Cut the baked strips into small tesserae, varying the sizes and shapes. Leave some uncut – you can cut them later if you need a very specific shape to fit a particular spot.
3. Spread a thin layer of liquid clay over the area to be covered in mosaic.
4. Cover the surface with tesserae, leaving small spaces for grout. *Tip:* If you have trouble getting the tesserae to go where you want, nudge them into position with a needle tool.
5. Bake at 275 degrees F. for 15 minutes. Remove from the oven and allow to cool.

Grout and Attach Pin Back:

1. For grout, mix about a 1/2 tsp. liquid polymer clay with a tiny dab of black oil paint. Follow the instructions in the Basic Techniques section for grouting with liquid polymer clay.
2. Bake at 275 degrees F. for 20 minutes. Allow to cool.
3. Texture one side of the 3/8" x 3/4" sheet of black clay. Spread a thin layer of liquid clay on the smooth side.
4. Flip the dog over so the textured side is up. Open the clasp of the bar pin. Place the bar pin in the center of the brooch. Firmly press the sheet of black clay, textured side up, over the bar pin. (It's like a piece of tape holding the pin to the brooch.)
5. Bake at 275 degrees F. for half an hour. Remove from oven and allow to cool.

Everyone is trying to accomplish something big, not realizing that life is made up of little things.

Frank A. Clark

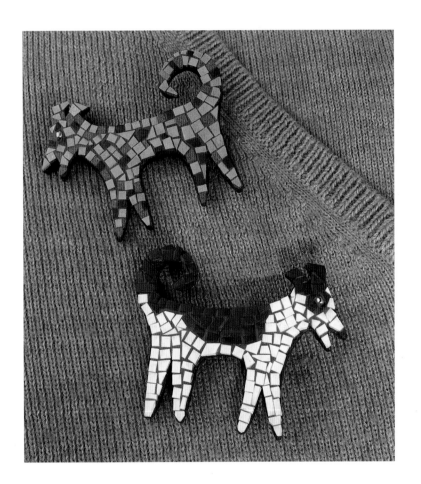

Finish:
1. Sand (if necessary), following the instructions for sanding in the Basic Techniques section.
2. Finish with two coats of polymer protectant. Allow each coat to dry for half an hour. ❏

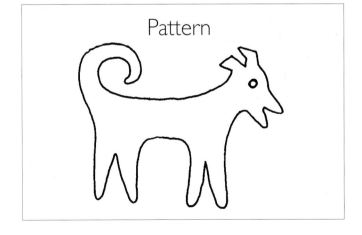

Pattern

ZIPPER PULL
WITH PIZZAZZ

Small and easy to make, this zipper pull adds a shot of charm to a drab jacket.
It gets the job done, too!

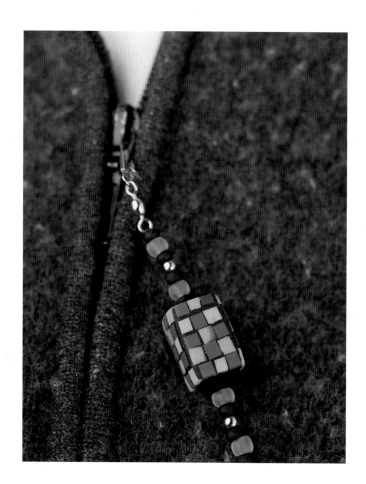

SUPPLIES

Polymer Clay:

Cube of black, 5/8" x 3/8" x 3/8"

Pinch of black

Each sheet should be 3/64" (1.2 mm) thick (#5 setting on pasta maker).

Sheet of blue, 1/2" x 1/2"

Sheet of purplish blue, 1/2" x 1/2"

Sheet of lime, 1/2" x 1/2"

Sheet of yellow, 1/2" x 1/2"

Other Supplies:

Liquid polymer clay, 1/4 tsp.

Black waxed thread *or* whipping twine, 6" long

Silver snap swivel, size 10 (Find this in the fishing tackle section of the hardware store.)

Crimp bead

Assorted glass and silver beads

Liquid polymer protectant

Equipment & Tools:

In addition to those listed on page 59.

Graph paper

Rubbing alcohol (for cleaning liquid clay brush)

Needle tool

Pliers

Optional: 1/16" drill bit

INSTRUCTIONS

Cut and Bake:
1. Place all the clay sheets on a glass cutting board. Use graph paper and the knife to cut each sheet into pieces just under 1/8" square. (See the Basic Techniques section for instructions on cutting tesserae.)
2. Bake at 275 degrees F. for 15 minutes. Remove from oven and allow to cool.

Create the Mosaic Bead:
1. Cover the four long sides of the black cube with tesserae, leaving a bit of space between them for grout. Press them into the cube firmly, but be careful that you don't distort the shape of the cube. Don't put any on the ends of the cube.
2. Stand the cube on its end and use a needle tool to pierce a hole in through the top and out through the bottom. *Tip:* Wiggle the needle tool around in the hole until it's big enough – you need to be able to run two pieces of waxed thread through it. *Option:* Make the hole after the cube is baked, using the drill bit and twisting it into the clay.
3. Bake at 275 degrees F. for 45 minutes.

Grout & Bake:
1. Mix a dab of liquid clay with a pinch of black clay. Follow the directions in the Basic Techniques section for grouting with liquid clay.
2. Bake at 275 degrees F. for 15 minutes. Remove from oven and allow to cool.

Finish:
1. Sand, following the instructions in the Basic Techniques section.
2. Apply two coats of polymer protectant. Allow each coat to dry for half an hour.
3. Loop the thread through the eye of the swivel (Fig. A).
4. Pass both ends of thread through the glass beads and mosaic bead and more glass beads, ending with the crimp bead (Fig. B). Close the crimp bead with pliers.
5. Trim the excess thread. ❏

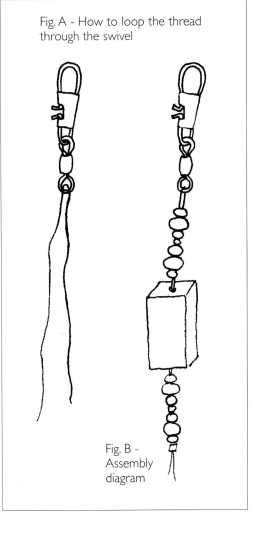

Fig. A - How to loop the thread through the swivel

Fig. B - Assembly diagram

HUMMINGBIRD PLANT STAKE

You can almost hear the hum of his wings. The tesserae in this project seem quite small; for comparison have a look at the whimsical micro-mosaics by Cynthia Toops or the very finely detailed quilt-like mosaics by Violette Laporte.

SUPPLIES

Polymer Clay Sheets:

About 3/32" (2.4 mm) thick (#2 setting on pasta maker)
2 sheets blue, 7" x 3-3/4"

About 1/16" (1.6 mm) thick (#4 setting on pasta maker)
Blue, 2-1/2" x 1/2"
Purple, 2-1/2" x 1/2"
Black, 3/4" x 1/2"
Metallic avocado green, 3" x 1/2"
Gold, 3" x 1/2"
White, 4" x 1/2"

About 1/8" (3.2 mm) thick (#1 setting on pasta maker)
Red, 2" x 2"
Black, 2" x 2"

Other Supplies:

Liquid polymer clay, 2 tsp.
Glass bead, 3/16" diam.
1/8" wooden dowel, 16" long
Gold embossing powder
Oil paint - ochre
Liquid polymer protectant

Equipment & Tools:

In addition to those listed on page 59.
1/4" cardboard cutting guides
Carbon paper or graphite paper
Rubbing alcohol (for cleaning liquid clay brush)
V-gouge linoleum cutter
Needle tool
Material for creating texture on clay

INSTRUCTIONS

Make the Base:

1. Add texture to one side of one 7" x 3-3/4" sheet of blue clay. (See the Beyond Basics section for instructions.) Place it, textured side down, on the glass cutting board.
2. Place the second 7" x 3-3/4" blue sheet on top and press together, being careful to avoid trapping air bubbles.
3. Make a template from Fig. A. Use it and the knife to cut out the base from the stacked blue clay sheets. (See the Basic Techniques section for instructions on making templates.) Use a rubber-tipped sculpting tool or your finger to smooth the cut edges, especially around the wing.
4. Carefully lift the bird from the glass and place it on a piece of paper.
5. From the leftovers of the blue stack, cut a piece 1-1/4"x 1/2". Set aside.

Embellish:

1. With a pencil, make a mark at 1-1/4" from one end of the dowel. Flip the bird so that the textured side is up. Press the dowel on the belly of the bird, lining up the pencil mark with the edge of the clay. Don't press all the way in – press just about half the thickness of the dowel. Remove the dowel.
2. Turn the bird so the textured side is down.
3. Use carbon paper or graphite paper and a copy of Fig. A to gently transfer the design details. (See the Basic Techniques section for instructions on transferring designs.)
4. Press the glass bead into the clay for the eye. Position the holes in the bead so they'll be hidden below the clay. (Grout will keep the bead in place.)
5. Using the 2" x 2" red and black sheets of clay, make a gradated ("Skinner blend") sheet, ending at #4 setting on the pasta maker. (See the Beyond Basics section for instructions.)
6. Make a template from Fig. B. Use this and the knife to cut out the beak from the gradated sheet. Position beak on the bird. Smooth it down by placing a small sheet of paper over it and rubbing lightly with your finger.
7. Make a template from Fig. C. Use this and the knife to cut out the neck detail from the #4 thickness of blue clay sheet. Position it on the bird, smoothing it as you did with the beak. (Lines on the neck will be carved after baking.)
8. Use carbon paper and a copy of Fig. C to gently trace the lines on the neck.

Cut Tesserae and Bake:

1. Place the remaining #4 thickness clay sheets on the glass board. Use cardboard cutting guides to cut the sheets into 1/4" strips. (See the Basic Techniques section for instructions on cutting tesserae.)

Continued on page 78

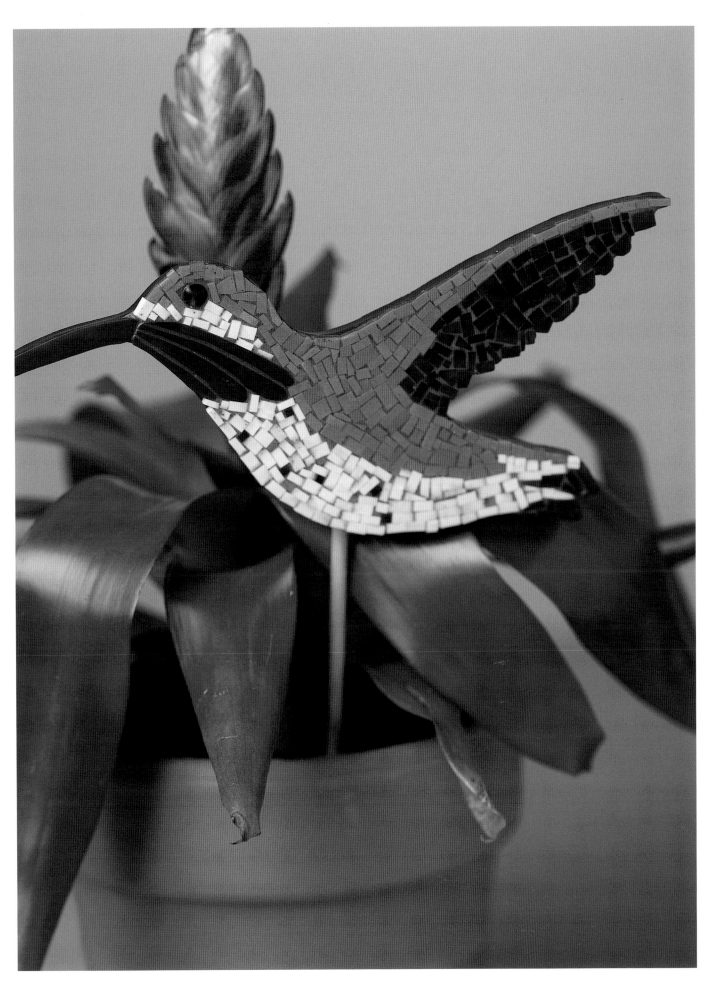

continued from page 76

2. Place the sheet of paper with the bird on the glass board. If there's no room, place the paper on top of the other clay.
3. Bake at 275 degrees F. for 1 hour, 15 minutes. Allow to cool in oven.

Create the Mosaic:

1. Cut the clay strips into small tesserae, varying the sizes and shapes. *Tip:* Leave some uncut so you can cut them later if you need a very specific shape to fit a particular spot.
2. Spread a thin layer of liquid clay over the area to be covered in mosaic.
3. Begin setting tesserae by following the pattern lines and using the project photo as a guide. Be sure to leave small grout spaces. *Tips:* I find it easiest to outline the small features first, so go around the eye, then the neck detail, then along the marks that indicate a change in color. If you have trouble getting the tesserae to go where you want, nudge them into position with a needle tool.
4. Bake at 275 degrees F. for 20 minutes. Remove from the oven and allow to cool.

Grout:

1. Use the v-gouge linoleum cutter to carve the grout lines on the neck.
2. For grout, mix about a tsp. of liquid clay with a sprinkle of gold embossing powder and a dab of ochre oil paint. Follow the instructions in the Basic Techniques section for grouting with liquid clay.
3. Bake at 275 degrees F. for 20 minutes.

Attach Dowel:

1. Turn the bird over so the textured side is up. Place the dowel in the groove.
2. Press the 1-1/4" x 1/2" piece of blue clay, textured side up, over the dowel like a piece of tape to hold the dowel on the back of the bird.
3. Bake at 275 degrees F. for 30 minutes. Allow to cool in oven. *Option:* If your oven is too small for the dowel to fit, carefully twist it out of the bird before baking, then use PVA glue to attach it after baking.

Finish:

1. Sand according to the instructions in the Basic Techniques section.
2. Finish with two coats of polymer protectant. Let dry half an hour between coats. ❏

Patterns

Fig. A

Fig. B

Fig. C

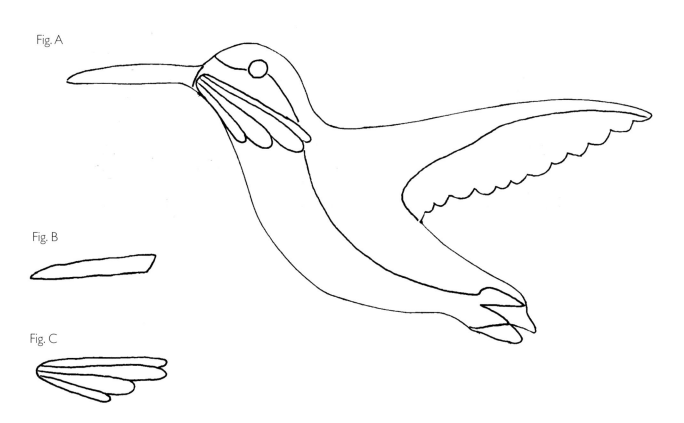

Byzantime Clock Pattern

See instructions on page 80

BYZANTIME CLOCK

The Byzantine Empire may not have had clocks, but their mosaic techniques are applied here to turn a plain modern timepiece into a work of art.

See pattern on page 79.

SUPPLIES

Polymer Clay Sheets:

About 1/8" (3.2 mm) thick (#1 setting on pasta maker)

Dark green, 5" x 5"

About 1/16" (1.6 mm) thick (#4 setting on pasta maker)

Dark green, 1-1/2" x 3/4"

Burgundy, 12-3/4" x 3/4"

Blue, 9" x 3/4"

Lime, 3-3/4" x 3/4"

Black, 3/4" x 3/4"

White, 1-1/2" x 3/4"

Other Supplies:

Liquid polymer clay, 1 Tbsp.

A couple of pinches each of blue and green polymer clay

Polyvinyl acetate (PVA) glue

Liquid polymer protectant

Clock kit

Equipment & Tools:

In addition to those listed on page 59.

3/4" cardboard cutting guide

Rubbing alcohol

5/16" drill bit and power drill

Carbon paper

Permanent marker

INSTRUCTIONS

Cut and Bake:

1. Place all the clay sheets on the glass cutting board.
2. Using the cardboard cutting guide and fine-tip craft knife, cut all the clay sheets that are 1/16" thick (#4 setting) into 3/4" squares. See the Basic Techniques section for instructions on cutting tesserae.
3. Use the long blade to cut the dark green tesserae into quarters diagonally to form small triangles. Do the same with the black tessera and with one of the burgundy tessera.
4. Cut all the white tesserae in half diagonally. Do the same with four of the lime squares and four of the burgundy squares. **Don't** cut the remaining 3/4" tesserae.
5. Bake all the tesserae and the 5" x 5" base at 275 degrees F. for 1 hour. Allow to cool in the oven.

Create the Mosaic:

1. Make a photocopy of the pattern. Follow the instructions in the Basic Techniques section to transfer the design to the clay base piece.
2. Apply glue to ("butter") the back of one tessera with glue and, using the project photo and transferred pattern as guides, place it firmly in position on the base. Continue until the mosaic is complete, remembering to leave grout spaces between each tessera. Allow to cure for 24 hours.

Grout:

1. For grout, mix liquid clay with a pinch or two of blue and green polymer clay.

2. Grout according to instructions in the Basic Techniques section for grouting with liquid clay.
3. Bake at 275 degrees F. Remove the mosaic from the oven. Place a piece of paper on top and weigh it down with a heavy book so it remains flat as it cools.

Finish:
1. Sand according to the instructions in the Basic Techniques section.
2. Using the 5/16 drill bit, drill a hole in the center of the mosaic for the clock works.
3. Apply two coats of polymer protectant. Let dry for half an hour between coats.
4. Install the clock kit on the mosaic. ❑

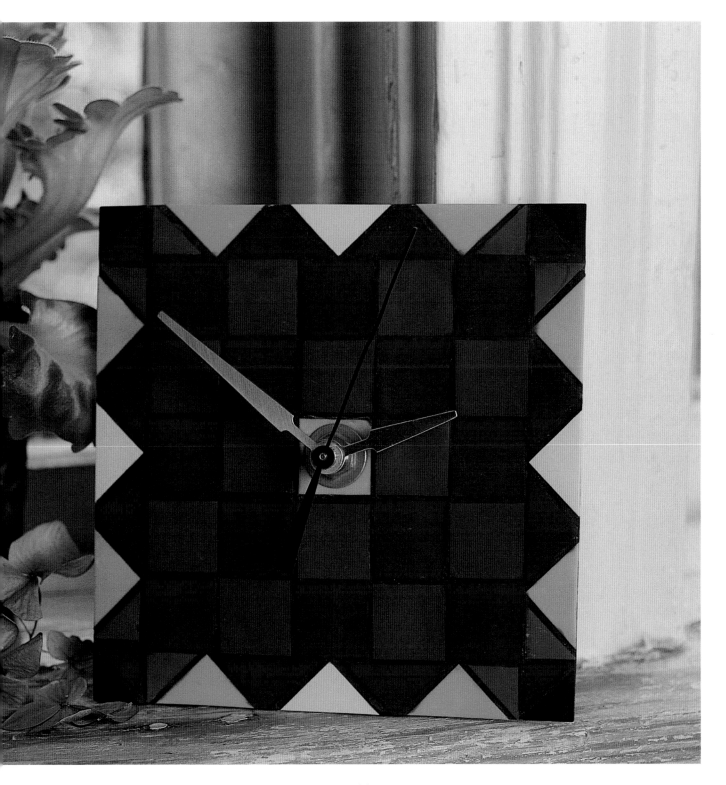

TEACUP TEA BOX

This project shows you how easy it is to add the look of a painted design to polymer clay tesserae with inkjet transfer paper. Imagine the possibilities! After transferring and baking, the tesserae are coated with liquid polymer clay and baked again for a durable finish.
A delightful tea box can transform an ordinary afternoon with friends into an occasion. If you're generous with your time and talent, make it as a gift for someone special.

SUPPLIES

Polymer Clay Sheets:

Each sheet should be approximately 1/6" (1.6 mm) thick (#4 setting on pasta maker).

White, 6-3/4" x 5-1/4"

Black, 5" x 1"

Lime, 5" x 1"

Other Supplies:

Liquid polymer clay, 1 Tbsp.

Polymer clay dilutent

Wooden box with lid surface measuring 8-1/2" x 6-1/2"

Sheet of inkjet t-shirt transfer paper

White premixed siliconized tile grout (a couple of tablespoons)

Clear waterbase varnish

Optional: Acrylic craft paint

Equipment & Tools:

In addition to those listed on page 59.

1/2" cardboard cutting guide

Carbon paper

Rubbing alcohol (to clean liquid clay brush)

Spoon

INSTRUCTIONS

Make the Transfer:

1. Scan the teacup design pictured on page 85 into your computer and print the design on transfer paper. *Option:* Take this book to a copy center and have them copy the design on the transfer paper for you.
2. Trim the transfer paper with the design 5" x 5".

Apply the Design and Bake:

1. Place the sheet of white clay on the glass cutting board. Position the transfer paper, image down, on the clay. Use a spoon to rub the paper all over, being careful not to miss any areas.
2. Leave the paper on the clay and bake at 275 degrees F. for 5-7 minutes. Remove from the oven and slowly peel off the paper. (The design will have transferred completely to the clay.)
3. Return the clay to the oven and bake for another 20 minutes. Allow to cool in the oven.
4. Place the black and green sheets of clay on the glass cutting board. Use 1/2" cardboard cutting guide and knife to cut the clay into 1/2" strips. (See the Basic Techniques section for instructions on cutting tesserae.)

Continued on page 84

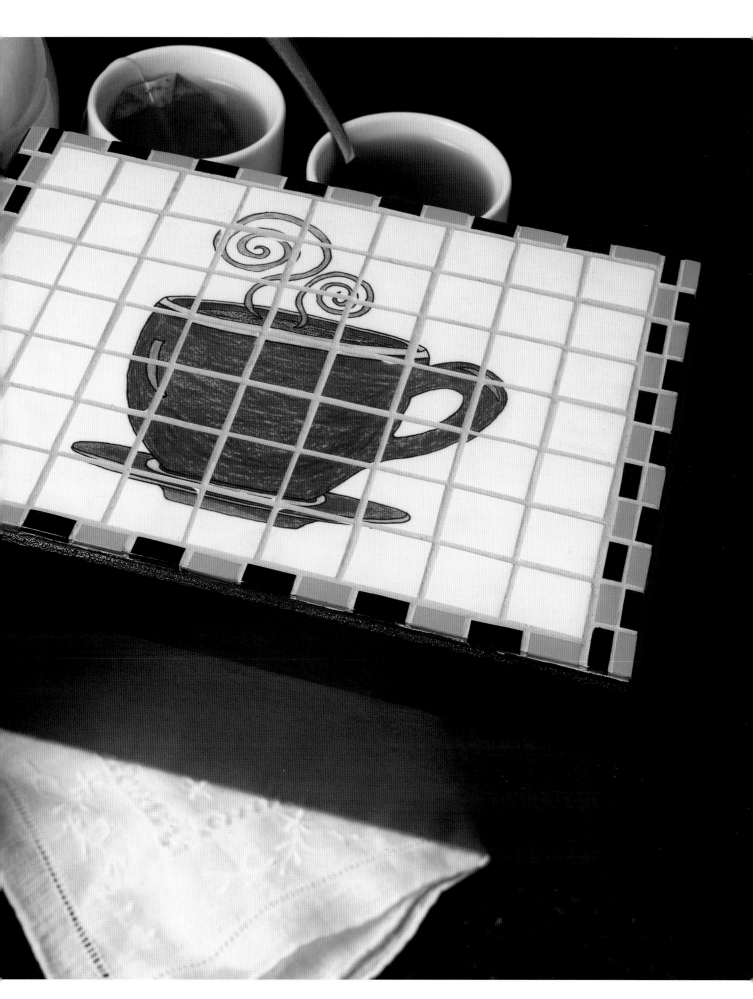

continued from page 82

5. Bake at 275 degrees F. for 45 minutes. Allow to cool in the oven.
6. Use a brush to spread a thin layer of liquid clay on the cup and saucer clay and the black and lime strips. *Tip:* If it's too thick, thin with a bit of dilutent.
7. Bake at 275 degrees F. for 20 minutes. Remove from oven and allow to cool.

Create the Mosaic:
1. Brush the top of the box with a mixture of equal parts water and PVA glue. Set aside until dry to the touch, about a half hour.
2. Cut the cup and saucer sheet into 3/4" tesserae.
3. Cut the black strips into 22 tesserae measuring 1/2" x 3/16" and 12 tesserae measuring 1/2" x 1/4".
4. Cut the lime strips into 22 tesserae measuring 1/2" x 3/16" and 14 tesserae measuring 1/2" x 1/4".
5. Use the project photo as a guide to arrange all the tesserae on the box lid.
6. When you're satisfied with the placement, remove one

tessera at a time, apply PVA glue to the back, and press the tessera in place. *Tips:* Start with the outer edge and work back and forth from side to side and top to bottom, allowing the glue to set a bit so the tessera has begun to adhere before you pick up the loose tessera beside it. This way you'll decrease the possibility of shifting the position of the glued tesserae. When complete, allow to cure for 24 hours.

Grout:
Follow the grouting instructions in the Basic Techniques section.

Finish:
1. Sand the mosaic, following the instructions in the Basic Techniques section.
2. Paint the exposed wood on the outside of the lid and the rest of the box with acrylic or latex paint. Allow to dry according to manufacturer's directions.
3. Finish by brushing two coats of varnish on the entire box, inside and out, including the mosaic. Let dry between coats. ❑

Knowledge is limited. Imagination encircles the world.

Albert Einstein

Pattern

What garlic is to salad, insanity is to art.

Augustus Saint-Gaudens

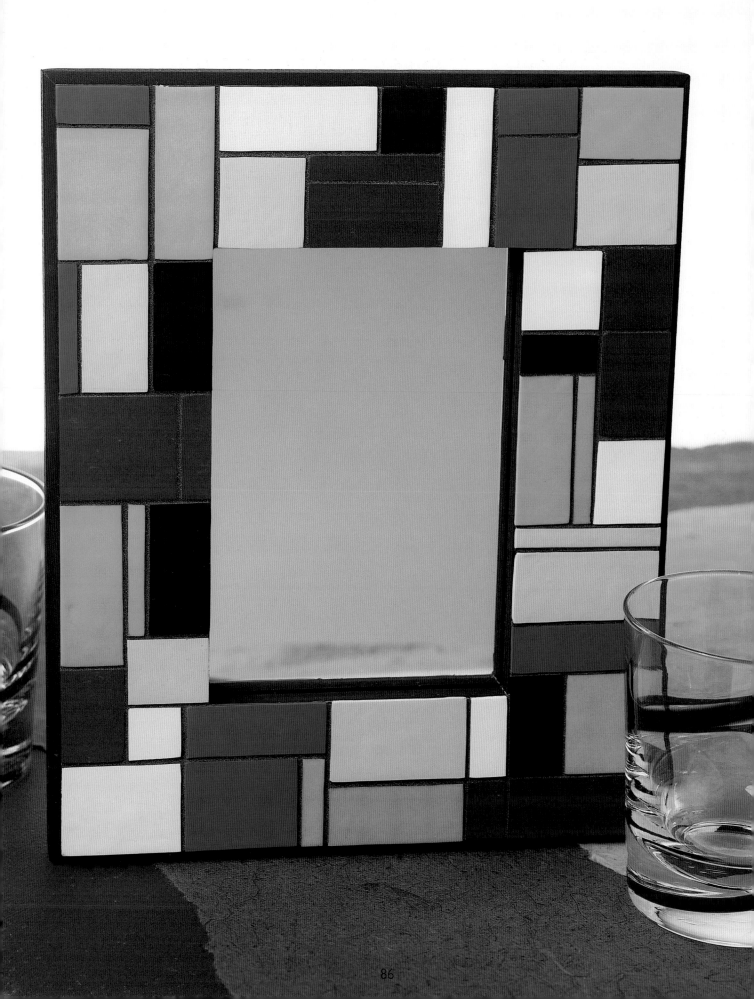

Thoroughly Modern Mondrian Mirror

Inspired by the work of artist Piet Mondrian, this framed mirror adds color, sophistication, and interest to a modern, stylish decor.

SUPPLIES

Polymer Clay Sheets:

*Each sheet should be about 1/16"
(1.6 mm) thick (#4 setting on
pasta maker).*

Red, 5-1/2" x 3"

White, 4" x 3-1/2"

Yellow, 5-1/2" x 4"

Gray, 5" x 3"

Blue, 5-1/2" x 2-1/2"

Black, 4-1/2" x 2"

Other Supplies:

Mirror with 2" wide wooden frame,
10-1/2" x 8-1/2"

Polyvinyl acetate (PVA) glue

Premixed siliconized tile grout -
silver/gray, approx. 3 Tbsp.

Acrylic craft paint - black

Liquid polymer protectant

Equipment & Tools:

In addition to those listed on page 59.

1/2" cardboard cutting guide

Cardstock

Carbon paper

INSTRUCTIONS

Cut and Bake:

1. Follow directions in the Basic Techniques section to make templates from Figs. A-F from the patterns provided.
2. Lay the sheets of clay on the glass cutting board. Use the templates and the knife to cut out the tesserae.
3. Bake at 275 degrees F. for 45 minutes.

Create the Mosaic:

1. Seal the surface of the mirror frame with equal parts water and PVA glue. Allow an hour to dry.
2. Make a photocopy of the assembly diagram on page 90. Following the instructions in the Basic Techniques section, transfer the pattern to the mirror frame.
3. Apply PVA glue to the back of each tessera and position in on the frame, using the pattern and the project photo to guide you. Allow space for grout. When complete, let the glue cure for 24 hours.

Grout:

1. Mix grout with just enough black acrylic paint to get a very dark grout.
2. Grout, following the instructions in the Basic Techniques section.

Finish:

1. Sand the mosaic, following the instructions in the Basic Techniques section.
2. Apply two coats of polymer protectant to the mosaic surface. Let each coat dry half an hour.
3. Paint exposed wood with black paint. ❏

We adore chaos because we love to produce order.

M. C. Escher

Templates for Tesserae

Fig. A - Red

Fig. B - White

Fig. C - Yellow

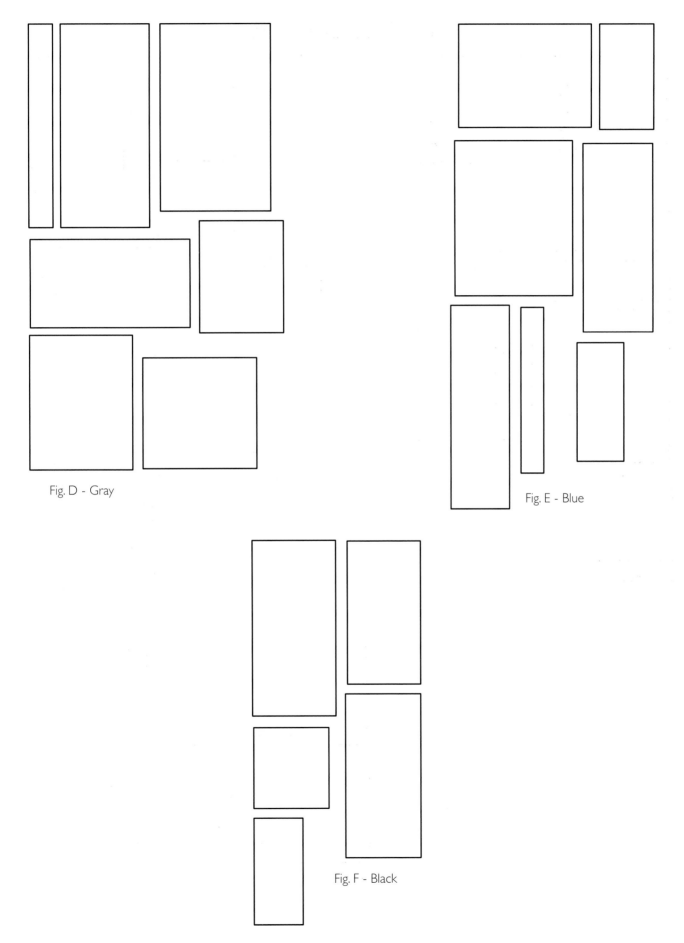

Fig. D - Gray

Fig. E - Blue

Fig. F - Black

Assembly Diagram

Enlarge 125% for Actual Size

BK = Black

B = Blue

G = Gray

R = Red

W = White

Y = Yellow

Gaudi-Inspired Switchplate

See instructions on page 92.

Base Pattern

GAUDÍ-INSPIRED SWITCHPLATE

Spanish architect Antoni Gaudí created wildly extravagant and bizarre buildings. He often employed the *pique assiette* method of using broken pieces of tile and other bits of found material to create mosaics on a multitude of surfaces, both inside and out. His work is the inspiration for this extravagant switchplate.

SUPPLIES

Polymer Clay:

Sheet of black, 8" x 5", 1/8" (3.2 mm) thick (#1 setting on pasta maker)

Sheet of black, 8" x 5", 3/32" (2.4 mm) thick (#2 setting on pasta maker)

Assorted polymer clay canes or millefiori (See the Beyond Basics section.)

Other Supplies:

Standard plastic lightswitch cover
Tip: I've found the dark-colored ones hold up better in the oven than the light-colored ones, which occasionally warp.

Polyvinyl acetate (PVA) glue

Premixed siliconized tile grout - white, approx. 2 Tbsp.

Acrylic paint in a color that works with the colors in your clay canes

Clear waterbase varnish

Optional: Oil paint (to paint the screw heads)

Equipment & Tools:

In addition to those listed on page 59.

1/2" cardboard cutting guide

Cardstock

Synthetic bristle brush (for glue, varnish, and paint)

Material for creating texture on clay

INSTRUCTIONS

Make the Base:

1. Coat the top of the plastic lightswitch cover with a thin layer of PVA glue. Allow half an hour to dry.
2. Place a sheet of paper on the glass cutting board. On the paper, stack the two black sheets of clay, one on top of the other. Avoid trapping air between the layers.
3. Place a sheet of paper on top and rub firmly to ensure that the two sheets of clay are joined. Remove the top sheet of paper.
4. Following the instructions in the Basic Techniques section, make template from the base pattern on page 91. Use it to cut out the base from the black double sheet of clay.
5. Place the plastic cover in the hole in the clay. Use your fingers to push the clay against the plastic until the clay slightly overlaps all the edges of the switchplate.

Create the Mosaic and Bake:

1. Cut 1/16" thick slices from various millefiori canes. *Tip:* You don't need to be too precise about the thickness of the slices – they represent broken pieces of a variety of tiles and plates, so they wouldn't be all of the same thickness. Just make sure they're thick enough to create channels between them to hold the grout.
2. Randomly tear and/or cut the slices into irregularly shaped pieces. Place the pieces on the base, cover the entire area with slices. Leave clear the openings for the switch and the screws. Tear and cut pieces to fit as you go along and leave space for grout around each piece.
3. When the entire surface is covered, place a sheet of white paper on top and rub firmly to ensure that the pieces stick to the base (formed by the black clay and the plastic switchplate).
4. Following the instructions in the Techniques section, add texture to the black edge to give a visual interest.
5. Bake at 275 degrees F. for 1-1/2 hours. Allow to cool in the oven.

Grout:

1. Mix grout with a bit of acrylic paint.
2. Grout, following the instructions in the Basic Techniques section.

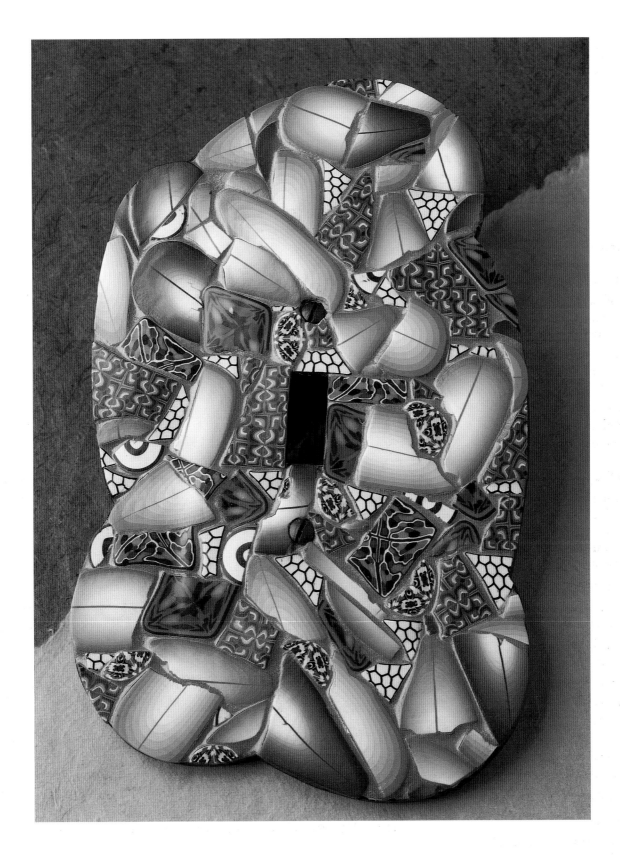

Finish:

1. Sand the mosaic, following the instructions in the Basic Techniques section.

2. Finish the mosaic surface with two coats of varnish, applying the varnish according to the manufacturer's directions.

3. *Option:* Paint the screws with oil paint. Let dry. ❏

TIMELESS TURTLE PLAQUE

The natural geometric quality of a turtle's shell makes it a perfect subject for
a mosaic. I used the mokumé gané technique to create the mottled look.
The background tesserae are placed using the opus vermiculatum method, following
the contour of the turtle.
Remember the saying "slow and steady wins the race"? It's a good motto to keep in
mind when working on mosaics that use small tesserae.

SUPPLIES

Polymer Clay Sheets:

Black - 1 sheet 5" x 5", 1/8"
(3.2mm) thick (#1 setting on pasta
maker)

*About 1/16" (1.6 mm) thick (#4
setting on pasta maker).*

Black - 4 sheets, each 2-1/2" square;
1 sheet, 3" x 1"

Metallic avocado green - 2 sheets,
each 2-1/2" square; 1 sheet,
3" x 1"

Pearl white - 2 sheets, each 2-1/2"
square; 1 sheet 1/2" x 1/2"

Gradated red to yellow, 5" x 4"

Brown, 2" x 1"

*About 1/8" (3.2 mm) thick (#1 setting
on pasta maker)*

Black, 5" square

Other Supplies:

Wooden base, 6" x 7-1/2"

2 screw eyes, 1/4"

Picture hanging wire, 6" long

Polyvinyl acetate (PVA) glue

Premixed siliconized tile grout - sil-
ver/gray, approx. 3 Tbsp.

Acrylic craft paint - green

Liquid polymer protectant

Equipment & Tools:

In addition to those listed on page 59.

1/4" cardboard cutting guide

Cardstock

Carbon paper

Drill bit (same diameter as the screw
eye shanks)

Hobby *or* hand drill

...take a line for a walk.

Paul Klee

Instructions follow on page 96.

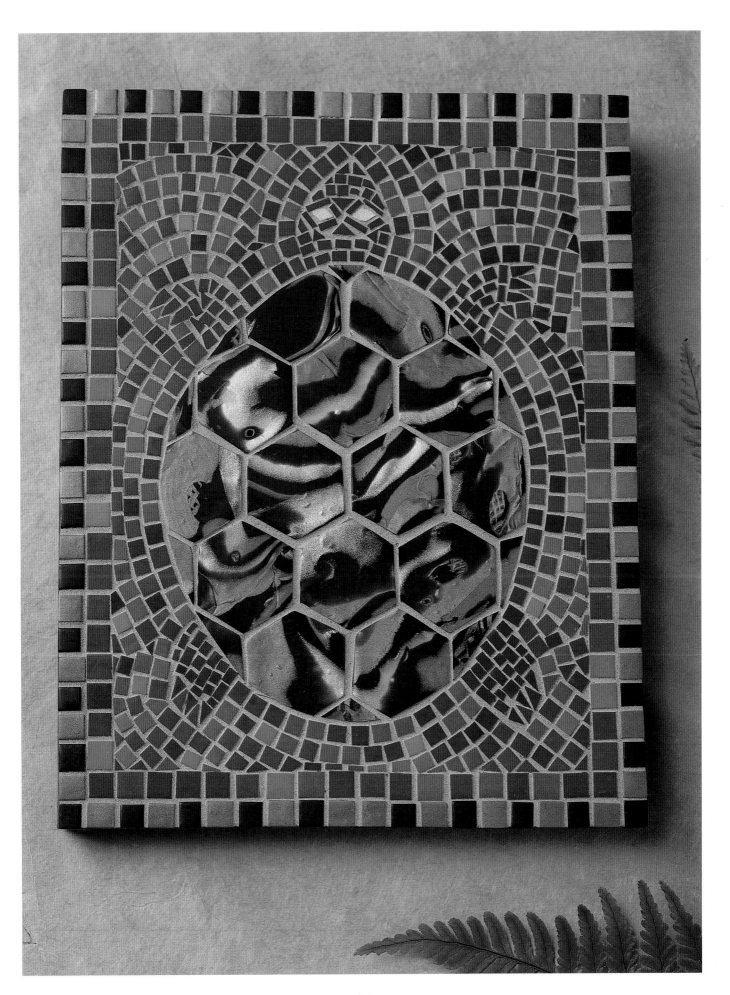

continued from page 94

INSTRUCTIONS

Cut and Bake:

1. Following the instructions in the Beyond Basics section, make a mokume gane block using the 2-1/2" square sheets of clay (4 black, 2 metallic avocado green, 2 pearl). (You'll have lots of the mokume gane left over for other projects.)

2. Place thin slices from the mokume gane block on the 5" x 5" sheet of black clay and run through the pasta maker on the #2, then #4 settings. Place on the glass cutting board.

3. Following the instructions in the Basic Techniques section, make a template from Fig. A (Pattern for Turtle Shell Tesserae).

4. Use the fine-tip craft knife and the template to cut 20 tesserae from the mokume gane sheet. Peel away the excess.

5. Lay the remaining sheets of clay on the glass cutting board. Use the cardboard cutting guide (see Basic Techniques section, cutting tesserae) and the knife to cut all the sheets into 1/4" tesserae.

6. Bake all the tesserae at 275 degrees F. for 45 minutes. Allow to cool in oven.

Create the Turtle Mosaic:

1. Make a photocopy of Fig. B (the Assembly Diagram). Follow the instructions in the Basic Techniques section to transfer the design to the wooden base.

2. Working one tessera at a time, use the rubber-tipped sculpting tool to apply glue to the backs of the mokume gane tesserae and set them in place, following the transferred design and the project photo as a guide. As you get to the edge of the turtle's shell, use a knife or blade to cut the tesserae to fit. (Refer to the Basic Techniques section, "Cutting Baked Tesserae.")

3. Cut the pearl white tesserae to match the eyes on the pattern. Dab a bit of glue on the base where the eyes go and press the tesserae firmly on the glue.

4. Cut the brown tesserae into smaller, randomly shaped pieces.

5. Use the rubber-tipped sculpting tool to spread a thin layer of glue on a small area (e.g., one of the turtle's feet, the head). Place brown tesserae firmly on the glue, filling in the pattern. Be sure to leave space for the grout. Continue until the turtle is complete.

Create the Border and Background:

1. For the border, spread a thin layer of glue on one edge. Using the project photo as a guide, place the 1/4" black and 1/4" green tesserae firmly on the glue. Continue until the outer row of the border is complete.

2. Use the gradated red to yellow 1/4" tesserae for the inner row of the border, gluing and placing as described above.

3. Cut the remaining red to yellow gradated tesserae into smaller, randomly shaped pieces.

4. Spread a thin layer of glue on a small area of the background and place the red to yellow gradated tesserae firmly on the glue. Continue gluing and placing tesserae until the mosaic is complete. Allow 24 hours to cure.

Grout:

1. Tint the grout with a few dabs of green acrylic paint.

2. Grout, following the instructions in the Basic Techniques section.

Finish:

1. Sand the mosaic, following the instructions in the Basic Techniques section.

2. Finish the mosaic surface with two coats of polymer protectant. Let each coat dry for half an hour.

3. Paint the edges of the wood with green acrylic paint. Allow to dry.

4. Drill two pilot holes for screw eyes on the back of the base. Space them 1-1/2" down from the top and 1" in from the sides.

5. Insert the screw eyes.

6. Thread the picture wire through the screw eyes and twist the ends back on the wire to secure.

Fig. A - Pattern for Turtle Shell Tesserae

Fig. B - Assembly Diagram

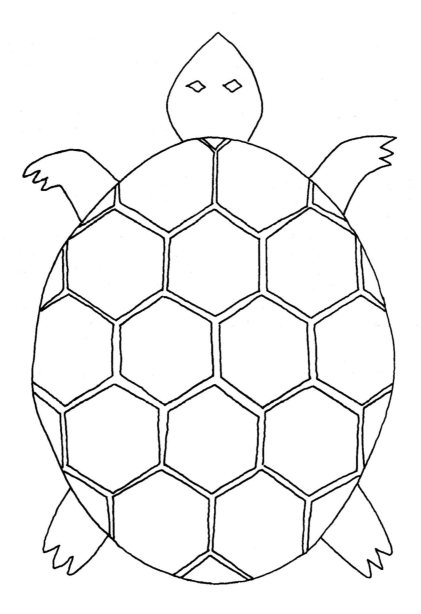

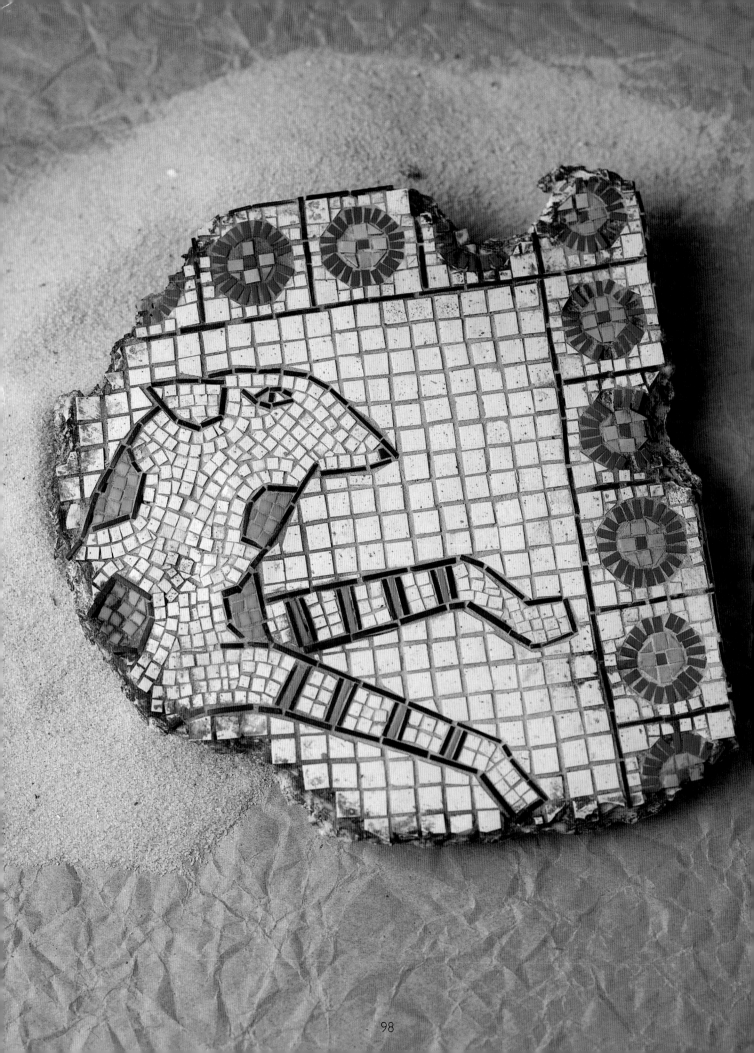

ANCIENT RUIN FRAGMENT

Hang this on the wall and watch your friends do a double-take! Tell them you picked
it up visiting an archeological dig on your last trip to Crete.
The beast in this design is derived from the Fourth Century Orpheus Mosaic
found at Withington, Gloucestershire, England. The border is similar to borders found
in mosaics on the Island of Crete, Greece.
To retain the aged look, do not sand or polish or add any finish to the piece.

SUPPLIES

Polymer Clay Slab:

*Use scrap clay in a variety of light
colors for a more realistic-looking
base.*

Various light colors, 7-1/2" square,
about 1/2" thick, hand-rolled
(Don't use the pasta maker – you
want a slightly uneven surface.)

Polymer Clay Sheets:

*Make each sheet 5/64" (2 mm) thick
(#3 setting on pasta maker).*

White, 8" x 5"

Blue, 12" x 3/16"

Black, 8" x 1/2"

Yellow, 3" x 1/2"

Tan, 2" x 1/2"

Other Supplies:

Liquid polymer clay, 1 Tbsp.

1/8 tsp. *each* of allspice, nutmeg, and
dirt

Premixed siliconized tile grout -
white, approx. 1/4 cup

Acrylic craft paint - burnt umber

Wood, 3" x 3" x 3/4"

2 screw eyes and hanging wire *or* a
keyhole hanging plate

Polyvinyl acetate (PVA) glue

Equipment & Tools:

In addition to those listed on page 59.

1/2", 1/4" cardboard cutting guides

Carbon paper

Old toothbrush

Rubbing alcohol (for cleaning liquid
clay brush)

Instructions follow on page 100.

 reativity is the sudden cessation
of stupidity.

Edwin Land

continued from page 99

INSTRUCTIONS

Make the Base:

1. Use the pattern to make a template for cutting out the base from the thick slab of clay. This piece is meant to look as though it's been ravaged by time, so make the cuts along the "broken" areas quite ragged. *Tip:* You can even tear the clay in the "broken" areas rather than cutting it.

2. Make a photocopy of the pattern. Following the instructions in the Basic Techniques section, transfer the design to the base.

Cut and Bake:

1. Use the spices to give the white clay an aged look, following the instructions in the Beyond Basics section for adding inclusions.

2. Place all the clay sheets on the glass cutting board. Use the cardboard cutting guides and follow the directions in the Basic Techniques section to cut the white, tan, and yellow sheets into 1/4" tesserae. Leave the black at 8" x 1/2". **Note:** The tesserae for this project are not sized precisely – I wanted them to look more handmade than manufactured. Each 1/4" tessera is really only *approximately* 1/4".

3. Place the base on a sheet of paper. Place on top of the clay sheets on the glass. Bake at 275 degrees F. for 1-1/2 hours. Allow to cool in the oven.

Create the Mosaic:

1. Spread a thin layer of liquid clay over the entire mosaic area.

2. Cut the 1/2" black strip into approximately 1/2" x 1/16" tesserae. (See Basic Techniques section, "Cutting Baked Tesserae".) *Tip:* Sometimes when you cut already baked tesserae they split due to trapped air in the clay. In this project, use the split tesserae to add to the aged and worn look of the piece.

3. Set the thin black tesserae on all the lines that make up the design of the beast. Make them smaller than 1/2" when necessary to follow the curve of the lines.

4. Set the black lines in the frame area.

5. Place the rest of the tesserae, cutting to size as you go.
 - The blue ones range from 3/16" x 1/16" to 3/16" x 3/32".
 - The tan ones are primarily 1/4" with a few cut diagonally in half.
 - The yellow leg stripes are 1/16" wide, then cut to length to fit the pattern.
 - The yellow spots are made of random sizes.
 - The white tesserae of the border are mostly 1/4", either left whole or cut in quarters, making them 1/8".
 - The white tiles of the beast are mostly 1/8".

6. Bake at 275 for 30 minutes. Allow to cool in the oven.

Grout:

1. Mix the grout with a bit of burnt umber acrylic paint.

2. Grout, following the instructions in the Basic Techniques section for grouting. Let cure.

3. Mix a bit of burnt umber acrylic paint with some dirt. Work the mixture into the surface of the piece where you want a particularly worn look. (*Tip:* An old toothbrush works well for this.) Use a damp rag to wipe off any areas that you feel have too much paint.

Finish:

1. Install screw eyes and wire or the keyhole hanging plate.

2. Use PVA glue to adhere the wood to the back of the mosaic. ❑

Pattern

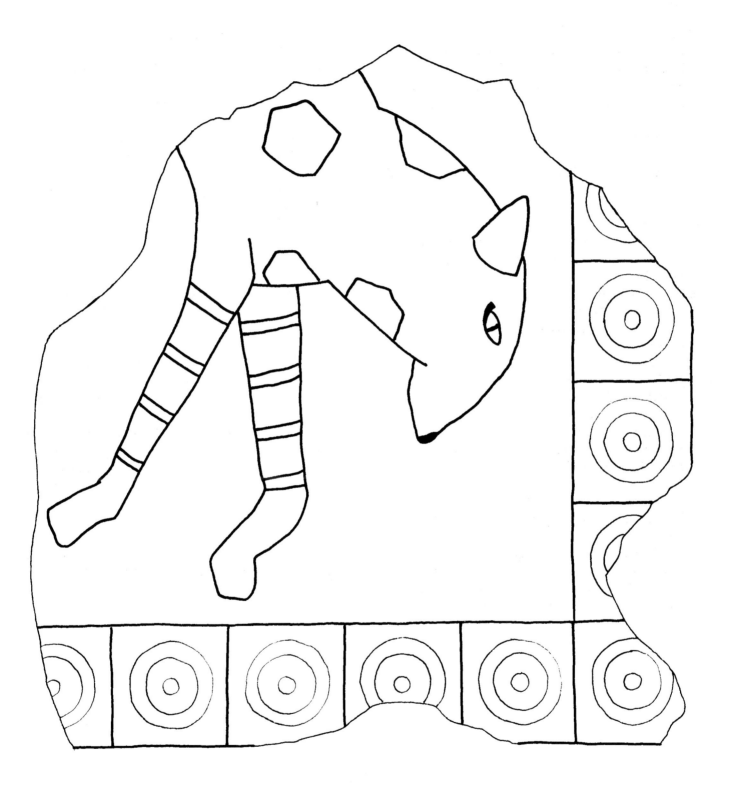

SALAD SERVERS

Here, polymer clay is used to decorate the handles of a pair of stainless steel salad servers. The delicious colors enhance the food they serve and your reputation as a creative host.
Choose servers with handles that won't allow the clay to slip off. Handles that flare at the end or have curves work well.

SUPPLIES

Polymer Clay Sheets:

Each should be about 3/32" (2.4 mm) thick (#2 setting on pasta maker).

Green-blue gradated ("Skinner blend") sheet, large enough to cover about three-quarters the lengths of the fronts and backs of the salad server handles

A small sheet of clay (I used purple) as a design accent

Other Supplies:

Stainless steel salad servers

Liquid polymer clay, 1 tsp.

Oil paint - color that complements clay color

Polyvinyl acetate (PVA) glue

Clear waterbase varnish

Equipment & Tools:

In addition to those listed on page 59.

Cardboard

V-gouge linoleum cutter

Rubbing alcohol

Optional: Cutters in various shapes

INSTRUCTIONS

Cut and Bake:

1. Make a cardboard template by tracing around about three-quarters of the length of the server handles. Cut out slightly larger than the actual traced lines. (This will ensure that you have enough clay to close the seams around the edges.)
2. Spread a thin layer of PVA glue on the handles where the clay will go. Set aside until dry to the touch, about a half hour.
3. Lay the large clay sheet on a sheet of white paper. Use the template and fine-tip craft knife to cut out four pieces from the clay sheet.
4. Place a piece of clay on the front of each handle, being careful not to trap air under the clay. Place another piece on each back. Pinch the front and back pieces together along the edges.
5. Use a cutter to cut out sections of clay from the handles.
6. Cut the same shapes from the sheet of accent clay and insert them into the holes you cut.
7. Place the salad servers on a sheet of paper on the glass cutting board.
8. Bake at 275 F. for 1 hour. Allow to cool in the oven.

Grout:

1. Use the v-gouge linoleum cutter to carve grout lines in the clay. Don't go too deep – just deep enough to create a trough for the grout.
2. For grout, tint 1 tsp. liquid polymer clay with a dab of oil paint.
3. Grout one side of each handle, following the instructions in the techniques section. (If you grout

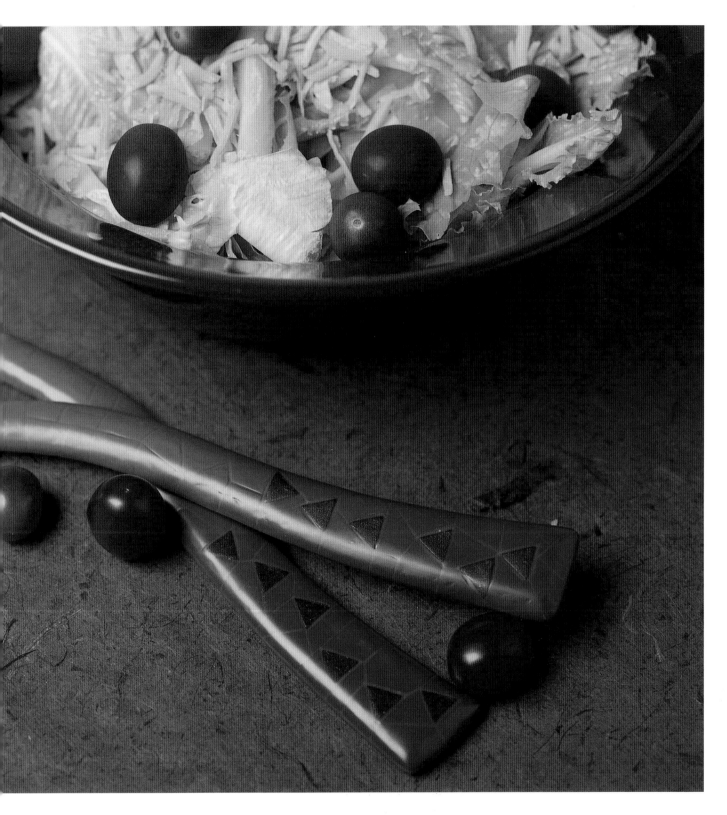

both sides at once, the grout will drip out of the underside.) Place the pieces, wet grout side up, on a sheet of paper on the glass cutting board.

4. Bake at 275 degrees F. for 20 minutes. Allow to cool.

5. Grout the other side and bake again.

Finish:

1. Sand according to the instructions in the Basic Techniques section.

2. Apply three coats of varnish to the polymer clay, following the varnish manufacturer's instructions. *Tip:* To care for your salad servers, hand wash in warm soapy water. ❑

TIDE TABLE

This piece is named for the patterns on a beach after the tide has gone out.
Swirls of sand and seaweed, time-worn rocks, and glistening pools of water are the
inspiration for this mosaic.

For a project that calls for a specific sized pre-made base, like a table or mirror, a substitute can be made simply from medium density fiberboard (MDF). For instance, an MDF top can be added to an existing table, or a mirror frame can be cut from MDF and a mirror affixed to the back with adhesive caulk.

SUPPLIES

Polymer Clay Sheets:

Each should be about 1/8" (3.2 mm) thick (#1 setting on pasta maker).

Black, 5" square

Red, 5" square

Gold, 5" square

Each should be about 1/16" (1.6 mm) thick (#4 setting on pasta maker).

Black - 12 sheets, each 2-1/2" square

Metallic avocado green - 2 sheets, each 2-1/2" square

Pearl - 2 sheets, each 2-1/2" square

Red - 2 sheets, each 2-1/2" square

Metallic purple - 2 sheets, each 2-1/2" square

Bronze - 2 sheets, each 2-1/2" square

Gold - 2 sheets, each 2-1/2"

Other Supplies:

Wooden table with top measuring 12-1/2" square

White polyvinyl acetate (PVA) glue

Premixed siliconized tile grout - white, approximately 1/3 cup

Acrylic craft paints - green, black

Clear waterbase varnish

Wood stain - walnut

Equipment & Tools:

In addition to those listed on page 59.

2" cardboard cutting guide

Sharp knife

INSTRUCTIONS

Make the Mokumé Gané Sheets:

1. Use a sharp knife to score the table top where the mosaic will go. (This gives a better grip for the glue.)
2. Seal the mosaic area with equal parts water and PVA glue. Allow to dry an hour.
3. Following the instructions in the Beyond Basics section, make three different mokumé gané blocks using the 1/16" thick (#4 setting) clay sheets stacked this way:
 Stack 1 - black, metallic avocado green, black, pearl, black, metallic avocado green, black, pearl
 Stack 2 - black, red, black, metallic purple, black, red, black, metallic purple
 Stack 3 - black, bronze, black, gold, black, bronze, black, gold
 (You'll have lots of the mokume gane left over for other projects.)
4. Place mokumé gané slices from Stack 1 on the 5" square sheet of black clay. Place slices from Stack 2 on the 5" square sheet of red clay. Place the slices from Stack 3 on the 5" square of gold clay.
5. Run each sheet through the pasta maker on the #2 setting, then #4 setting.

Cut and Bake:

1. Use the cardboard cutting guide to cut 2" x 2" tesserae, 12 from each of the three mokume gane sheets. (See the Basic Techniques section for instructions on cutting tesserae.)
2. Bake on glass cutting board for one hour at 275 degrees F. Allow to cool in the oven.

Create the Mosaic:

1. Arrange the tesserae on the table top, leaving space for grout.
2. When you're pleased with the design, remove one tessera at a time, "butter" the back with PVA glue, and press into position. Continue until mosaic is complete. Allow 24 hours to cure.

Grout:

1. Mix grout with a bit of black and green acrylic paint.
2. Grout, following the instructions in the Basic Techniques section.

Finish:

1. Sand, following the instructions in the Basic Techniques section.
2. Finish mosaic surface with three coats varnish, following the varnish manufacturer's instructions.
3. Stain the exposed wood, following the stain manufacturer's instructions. ❑

KLIMT-INSPIRED BACKSPLASH

Austrian painter Gustav Klimt's *The Kiss* is the inspiration for this backsplash.
I've taken my cue from the mosaic style that dominates the piece, as well as Klimt's
use of golden decoration.
It looks like a difficult project, but don't be fooled – the techniques are quite basic.
The project measures 72" × 16" and takes approximately 4 lbs. of clay. The amount of
clay you will need depends on the size of your piece. (One pound of clay at the #3
setting on the pasta machine covers about 275 sq. in. (27-1/2" × 10", for example).)
The project has many possibilities, and the design is easy to adapt to
a space of any size.

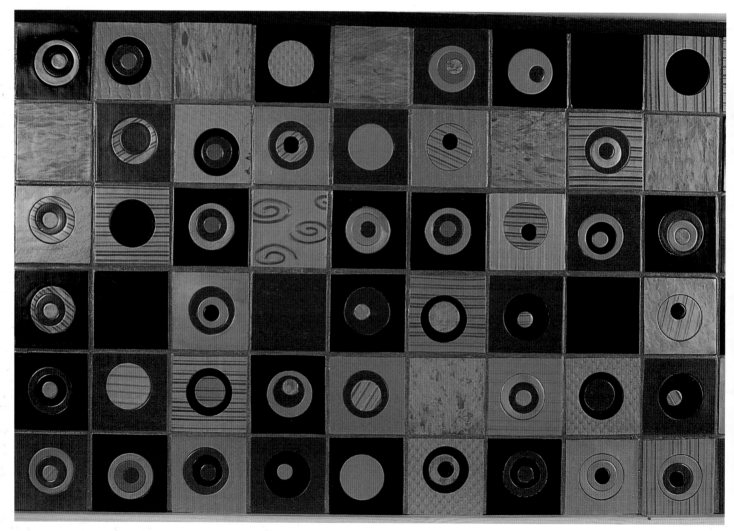

Photography by Julian Beveridge

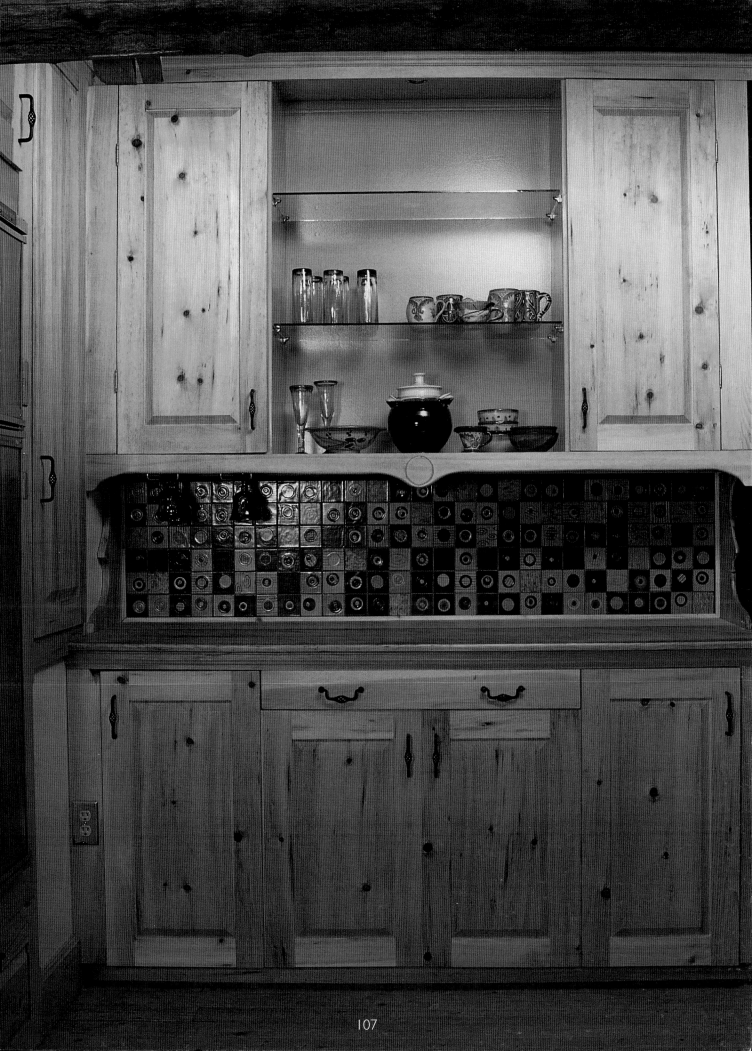

SUPPLIES

Polymer Clay:

Various colors (I used black, gold, metallic avocado green, red, and a bit of orange.)

Other Supplies:

1/4" plywood *or* medium density fiberboard (MDF), cut to fit your backsplash area

White polyvinyl acetate (PVA) glue

Premixed siliconized tile grout - white

Acrylic craft paint - color of your choice (for tinting grout)

Clear waterbase varnish

Vinyl adhesive caulk (for mounting)

Equipment & Tools:

In addition to those listed on page 59.

Circle cutters, 1-1/2", 1", 1/2" diameter

Smooth ceramic tile

Optional: Clear tape, 2" wide

INSTRUCTIONS

Prepare the Surface:

1. Use a blade to score the board where the mosaic will be placed. (This gives a better grip for the glue.)
2. Seal every surface of the board with equal parts water and PVA glue. Let dry.

Make the Tiles:

1. Decide what size tiles you want for your project. (Mine are 2-1/2" square. With space for grout (3/16" between each tile) I have 27 tiles horizontally by 6 tiles vertically to fit my space.)
2. When you've decided on the tile size, roll out an appropriate amount of clay 5/64" (2 mm) thick

"A pleasant illusion is better than a harsh reality."

Christian Nevell Bovee

(#3 setting on the pasta maker). Use a variety of colors. For added visual interest, follow the instructions in the Beyond Basics section for creating mica shift patterns with metallic clays.

3. Make a cardboard template 10" to 12" long and as wide as you want your tiles to be.
4. Following the instructions in the Basic Techniques section, use the template and the knife to cut the clay sheets into tiles.
5. Use the circle cutters to cut 1-1/2" circles from some of the square tiles. (Don't cut them all – leave some solid-color tiles.) Set aside the cut out circles.
6. Re-assemble the circles and squares, mixing up the colors.
7. Use the 1" cutter to cut circles from the 1-1/2" circle area made previously. Repeat with the 1/2" cutter. If you like, mix up the pattern occasionally by only using the 1" or 1/2" cutter on the square, or leave the 1-1/2" circle without cutting smaller circles from it. Re-assemble the tiles, mixing up the colors.
8. When you've made enough tiles, place them on clean sheets of paper. Stack the sheets on top of each other and place on the glass cutting board. Top the stack with a sheet of paper and add a ceramic tile to keep the stack flat during baking and cooling.
9. Bake at 275 degree F. for 2 hours. Allow to cool in oven.

Create the Mosaic:

1. Arrange the tiles on the base, leaving space for grout.
2. When you're pleased with the design, remove one tile at a time, "butter" the back with PVA glue, and press into position. Continue until all the tiles are glued down. Allow 24 hours to cure.
3. *Option:* If you don't want grout in the tiny lines around the circles, cover them with clear tape. **Don't** put tape over the areas to be grouted.
4. Tint an appropriate amount of grout with acrylic paint.
5. Grout, following the instructions in the Basic Techniques section. Let dry completely. Remove any tape.

Finish:

1. Sand according to the instructions in the Basic Techniques section.
2. Finish the mosaic surface with three coats of varnish, following the varnish manufacturer's instructions.
3. Mount the backsplash on the wall with vinyl adhesive caulk. Caulk where the backsplash joins the counter. ❏

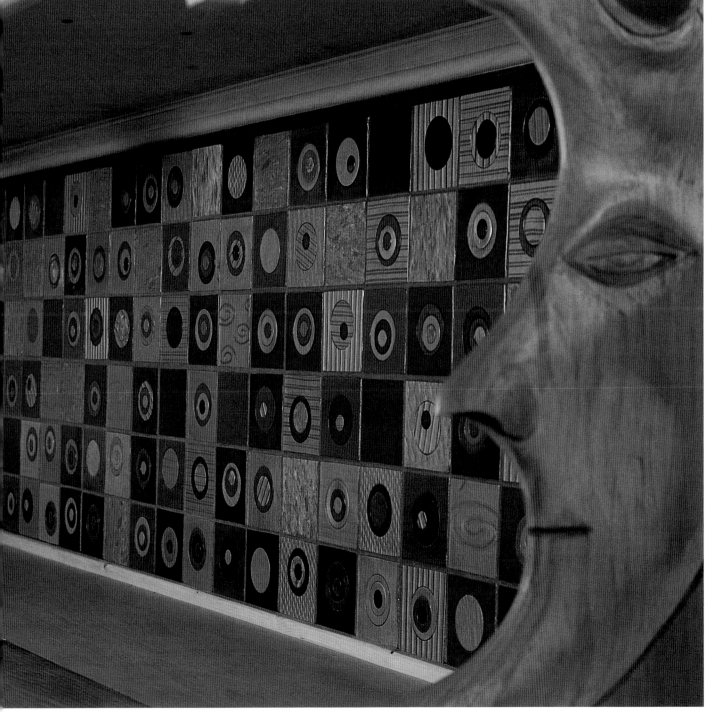

Carving by Michael Fuller

FISH TABLE

Riotous color makes this fish table the focal point of any room.
The borders add an intriguing three-dimensional effect.

SUPPLIES

Polymer Clay:

Various colors, 0.8 lb. (360 gm.) in
all, in sheets 1/16" (1.6 mm) thick
(#4 setting on pasta maker)

Other Supplies:

Table with 20" x 14-1/2" top

White polyvinyl acetate (PVA) glue

Premixed siliconized tile grout -
white, approximately 1/2 cup

Clear waterbase varnish

Acrylic craft paint (optional)

Latex paint *or* wood stain (for table
apron and legs)

Equipment & Tools:

In addition to those listed on page 59.

Assorted cardboard cutting templates

Carbon paper

Smooth ceramic tile

Sharp knife

INSTRUCTIONS

Prepare the Surface:

1. Use a sharp knife to score the table top where the mosaic will go. This gives a better grip for the glue.
2. Seal the tabletop with a mixture of equal parts water and PVA glue. Allow to dry.
3. Make a photocopy of the pattern, enlarging it 125%.
4. Following the instructions in the Basic Techniques section, transfer the fish design to the center of the table.

Make the Tesserae:

Be sure to make some gradated ("Skinner blend") sheets (see the Beyond Basics section) to give subtle color variation. The tesserae for the fish section are primarily odd shapes and sizes. If you have leftover tesserae from other projects, this is a great place to use them.
Cut the sheets of clay into tesserae of various sizes and shapes. The background consists of 1/2" and 3/4" square tiles, some 1/2" 60-degree diamonds (use Fig. A as a guide), and a few triangles and odd bits to fill in odd-shaped spaces.
To make the diamonds, place a sheet of clay on the glass cutting board and use a 1/2" cardboard cutting template to cut a 1/2" strip of clay. Make a photocopy of Fig. A. Place the cutting board over the photocopy, lining up the clay strip with the long parallel lines of the diagram. Use the short parallel lines to line up your blade. Press down the blade (don't drag it!) to cut.

Bake:

Leave all the tesserae on the glass cutting board. Bake at 275 degrees F. for 1 hour. Allow to cool in the oven. *Tip:* You probably won't have enough room on the cutting board for all the tesserae so place some on a sheet of white paper and place it on top of the other tesserae. Place another sheet of paper on top and weigh it down with a ceramic tile, smooth side down, to ensure that the tesserae remain flat.

Continued on page 112

Divide each difficulty into as many parts
as is feasible and necessary to resolve it.

René Descartes

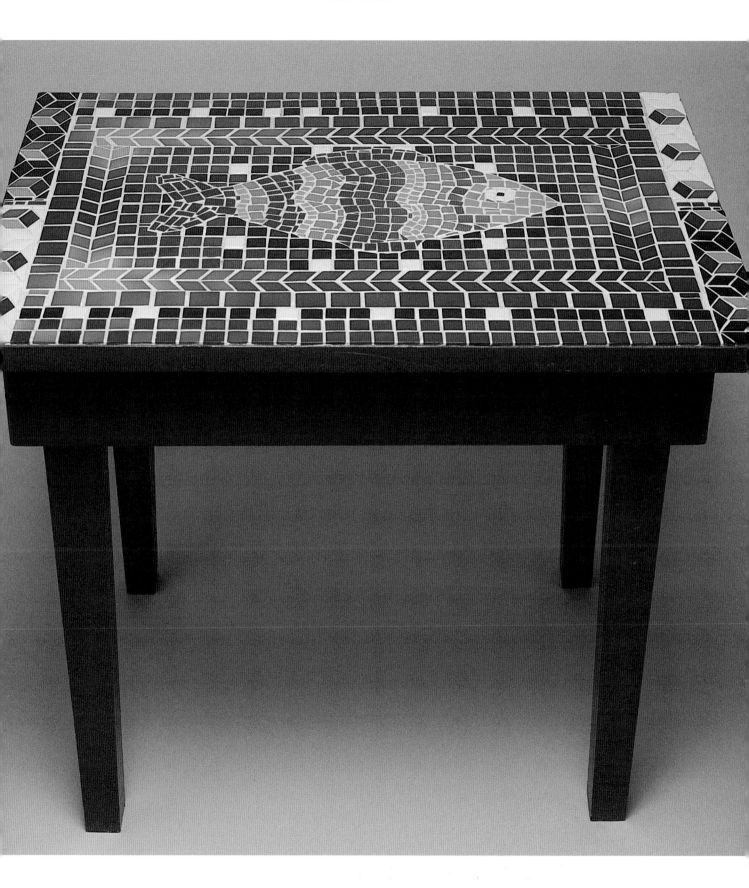

continued from page 110

Create the Fish Mosaic:
Spread a thin layer of PVA glue on a small section of the fish area, and fill in one color at a time. "Butter" the back of each tessera with PVA glue and set it firmly in place. Choose the sizes and shapes at random but avoid using any larger than 1/2" square. Follow the project photo as a guide.

Add the Background:
When you've completed the fish, move on to the background. See the "tips" that follow. Let dry 24 hours.

Symmetrical Background Option:
1. Place your background tesserae on the lower half of the table top, but don't glue them. Arrange them until you're happy with the result.
2. Using what you've just done as a guide, repeat the pattern on the upper half of the table top, this time gluing them in place as you go. Once you've completed the upper half, glue the lower half in place. Let dry 24 hours.

Grout:
Follow the instructions in the Basic Techniques section to grout the mosaic. Let dry completely.

Finish:
1. Sand according to instructions in the Basic Techniques section.
2. Seal the tabletop with three coats of waterbase varnish, following the varnish manufacturer's instructions.
3. Finish the exposed wood surface of the table with latex paint or wood stain – your choice. *Tip:* If you decide to paint the table, take a few tesserae to the paint store and have a paint mixed to match them. ❏

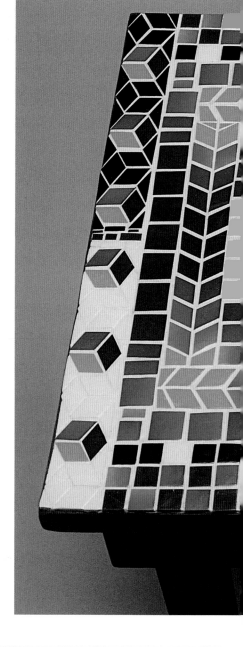

Tips for Adding the Background

• If you're going for a grid look, cut the tesserae around the fish to follow the contour of the fish. (See the Techniques section, "Cutting Baked Tesserae.")

• Before you commit to an arrangement for the background, lay out a small section on the tabletop to see how it looks. If you like, vary the size of the tesserae from one row to the next. You might try three rows of 1/2", then one row of 3/4".

• Keep the grout space about 3/32". (Measure a few,

then use your eye to space the rest.)

• Occasionally you'll need to fiddle with the spacing to make something work.

• To make the fish stand out, I did the background in *opus tessellatum*, using 1/2" square tesserae immediately behind the fish and various sizes to create the border.

• If you aren't sure if you can lay the tesserae in straight rows by eye, draw out some grid lines on the table top to use as a guide.

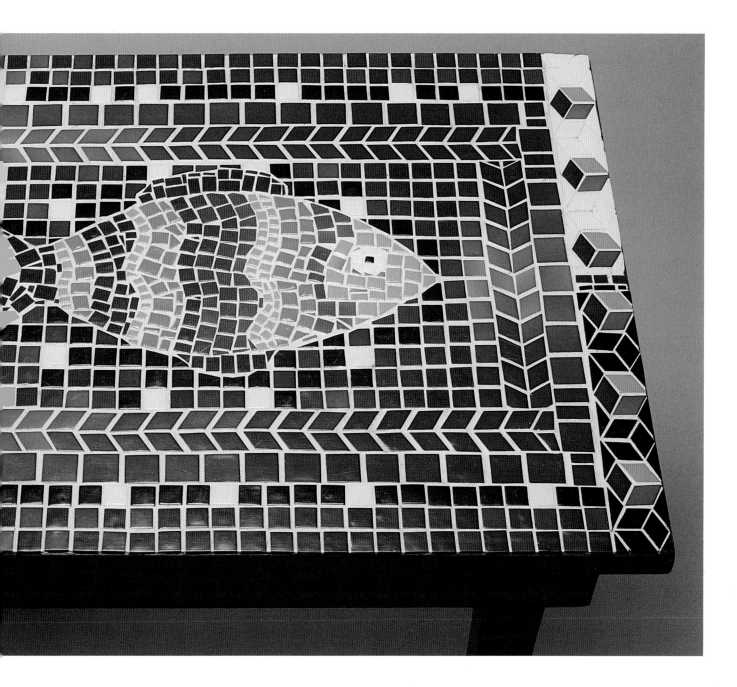

Fig. A - Diamond Cutting Guide
(60-degree diamonds)

Fish Table Pattern

Enlarge @125% for actual size.

GECKO DOOR

Those darn geckos! When they're out, they want in. And when they're in – well, you know.
The mosaic area of this project measures 555 sq. in. and uses approximately 2 lbs.
of polymer clay. The amount of clay you need depends on the size of your door panels
– 1 lb. of clay at the #3 setting on the pasta machine covers about 275 sq. in.
(27-1/2" × 10", for example). The sculpted geckos use about 2.3 oz.
of polymer clay each.

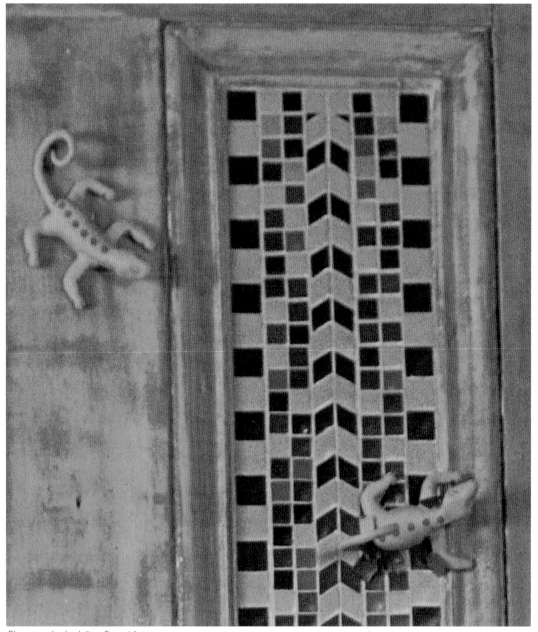

Photography by Julian Beveridge

Instructions follow on page 116.

Using different color gradations for the door panel tesserae produces a stained-glass effect. The upper panels have sections that shade from red to yellow and yellow to lime. The lower panels have sections that shade from lime to yellow and lime to blue/green. The color shifts are interrupted by a variety of colored tesserae, producing a more interesting effect than simple gradation. (To make gradated tesserae, see the Beyond Basics section.)

This project is easier if you remove the door from its hinges so that it lies flat as you work.

SUPPLIES

Polymer Clay:

Various colors – 2 lbs. in all

A few millefiori canes (for details on the geckos)

Other Supplies:

Wooden door with inset panels

White polyvinyl acetate (PVA) glue

Premixed siliconized tile grout - white, approximately 1 cup

Acrylic craft paint - color of your choice (for tinting grout)

Clear waterbase varnish

Stiff wire

Equipment & Tools:

In addition to those listed on page 59.

Sheet of stiff cardboard

Assorted cardboard cutting guides

Smooth ceramic tile

Sharp knife

INSTRUCTIONS

Make the Tesserae:

1. Measure the panels of your door.
2. Roll out an appropriate amount of clay sheets 5/64" (2 mm) thick (#3 setting on the pasta maker). Use a variety of colors.
3. Cut the sheets into squares of various sizes, triangles, and 60-degree diamonds that range from 3/4" to 1/2" (Fig. A). Use cardboard cutting guides and follow the directions in the Basic Techniques section.
4. Stack the tesserae in layers with sheets of paper between the layers. On the top of the stack, place a sheet of paper and put a ceramic tile on top to keep the tesserae flat as they bake and cool.
5. Bake on the glass cutting board at 275 degrees F. for 1 to 2 hours. (The timing depends on how thick your stack of tesserae and paper is.) Allow to cool in the oven.

Prepare the Door:

1. Use a sharp knife to score the area of the door where the mosaic will go. (This gives a better grip for the glue.)
2. Seal the mosaic area with equal parts water and PVA glue. Allow an hour to dry.

Create the Mosaic:

1. Arrange the tesserae on door panels, leaving space for grout.
2. When you're pleased with the design, remove one tessera at a time, "butter" the back with PVA glue, and press into position. Leave some tesserae unglued in the areas where the geckos will be placed. Continue until all the other tesserae are glued down. Allow 24 hours to cure.

Continued on page 118

nspiration follows aspiration.

Rabindranath Tagore

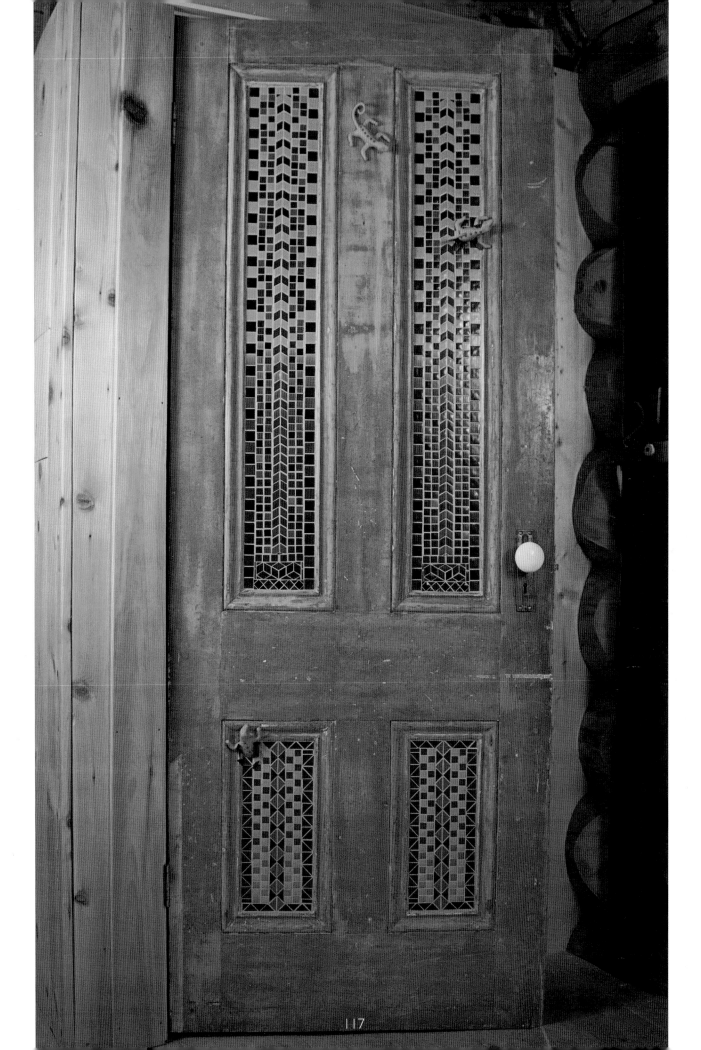

continued from page 116

Add the Geckos:
1. Sculpt three geckos from green clay.
 - Use a piece of stiff wire covered with clay for the tails.
 - Add contrasting slices of millefiori for the eyes and spots on the backs.
 - On one gecko, omit the lower torso. Another needs only three legs. (This leaves the impression, of course, that the body parts that aren't there are under the mosaic.)
 - When sculpting the parts of the geckos that make contact with the door, make a flat area to ensure good adhesion.
2. Bake at 275 degrees F. for 1-1/2 hours. Allow to cool in the oven.
3. Remove as many of the unglued tesserae as needed to make room for the geckos.
4. Use PVA glue to fix the geckos in position. Allow one hour to set.

5. Being careful not to dislodge the geckos, finish gluing the tesserae around them.
6. Glue a few tesserae onto the backs of the geckos and a few broken ones on top of the other tesserae, as if they had shattered when the gecko broke through. Allow 24 hours to cure.

Grout:
1. Mix an appropriate amount of grout with a bit of acrylic paint to tint it to a color suitable for the colors you've used for the mosaic.
2. Grout the mosaic, following the instructions in the Basic Techniques section.

Finish:
1. Sand, following the instructions in the Basic Techniques section.
2. Finish the mosaic surface with three coats of varnish, following the varnish manufacturer's instructions. ❏

Fig. A - Template for 60 degree diamonds

Art Deco Shelf Patterns

See instructions on page 120.

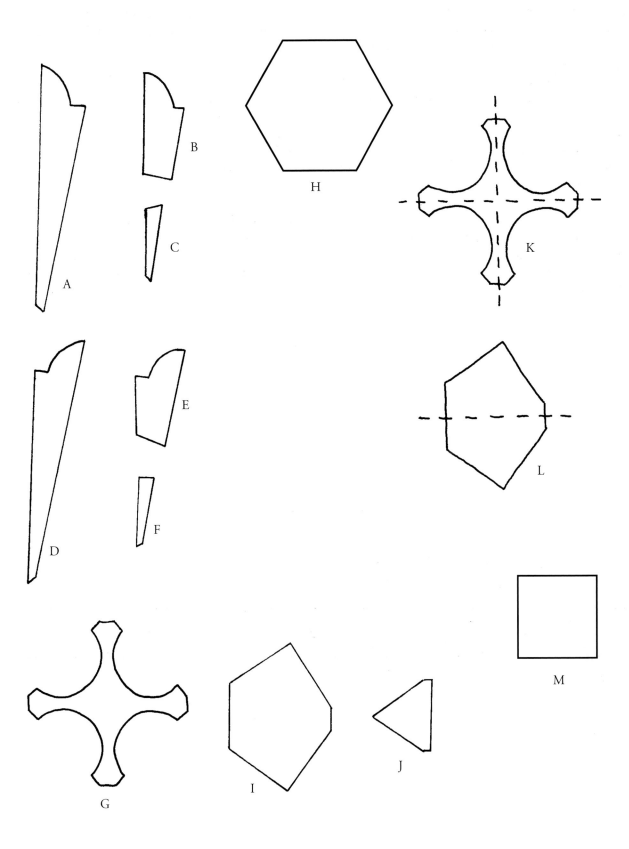

ART DECO SHELF

This is a stunning design for a shelf in the perennially popular Art Deco style.

SUPPLIES

Polymer Clay Sheets:

Each should be about 1/16" (1.6 mm) thick (#4 setting on pasta maker).

Metallic avocado green, 12" x 5"

Yellow, 9" x 3"

Orange, 9" x 3"

Black, 6-1/2" x 2"

Other Supplies:

Wooden shelf unit with top measuring 17-1/2" x 6"

Premixed siliconized tile grout - silver/gray, about 1/4 cup

Acrylic craft paint - green

Polyvinyl acetate (PVA) glue

Liquid polymer protectant

Wood stain - walnut

Equipment & Tools:

In addition to those listed on page 59.

3/4", 1/4" cardboard cutting guides

Paper and/or cardstock

Carbon paper

Craft brush (for glue)

Synthetic bristle brush (for wood stain)

Smooth ceramic tile

Sharp knife

Permanent marker

INSTRUCTIONS

Prepare the Surface:
1. Use the knife to score the surface of the shelf where the mosaic will go. (This gives a better grip for the glue.)
2. Seal the mosaic area with a mixture of equal parts water and PVA glue. Allow an hour to dry.
3. On the top of the shelf mark the center lines (length and width) and the border lines (sides, 1-1/8" from edges; front and back, 3/8" from edges).

Cut and Bake:
Follow the instructions in the Basic Techniques section.
1. Use the pattern provided to make templates.
2. Using the templates, cut these tesserae:
 Orange - 12 of Fig. A; 12 of Fig. B; 12 of Fig. C
 Yellow - 12 of Fig. D; 12 of Fig. E; 12 of Fig. F
 Metallic avocado green - 6 of Fig. G; 6 of Fig. H; 12 of Fig. I; 12 of Fig. J
3. Using cardboard cutting guides and/or a ruler, measure and cut:
 Black - 6 each 7/8" square (Fig. M); 65 each 1/4" squares for border
 Metallic avocado green - 65 each 1/4" squares for border
 Yellow - 10 each 3/4" squares for side border
 Orange - 10 each 3/4" squares for side border
4. Leave the tesserae lying flat on the glass cutting board. If they don't all fit on the glass, place some tiles on sheets of paper and stack the sheets. Put a final sheet of paper on top and weigh down with a smooth ceramic tile to keep the tesserae flat during baking.
5. Bake at 275 degrees F. for 1 hour. Allow to cool in the oven.

Continued on page 122

 Don't measure yourself by what you accomplished, but by what you should have accomplished with your ability.

John Wooden

continued from page 120

Transfer the Design:

1. Cut a sheet of carbon paper 7-5/8" x 5-1/8". Place it so one edge lines up with the center line and fits within the border lines.
2. Place a photocopy of the Assembly Diagram on top, lining it up with the center mark. Transfer the design. *Tip:* You need not trace all the lines – just enough to guide you as you're setting the tesserae.
3. Move the carbon paper and design into the same position on the other half of the shelf and trace again.
4. Trace over the lines with a permanent marker.

Cut:

When the tesserae are cool, use the long blade to cut them:

Cut 64 metallic avocado green 1/4" tesserae diagonally in half.

Cut 1 metallic avocado green 1/4" tessera diagonally in quarters.

Cut 64 black 1/4" tesserae diagonally in half.

Cut 1 black 1/4" tessera diagonally in quarters.

Cut 1 black 7/8" tessera in half.

Cut 8 yellow 3/4" tesserae diagonally in half.

Cut 2 yellow 3/4" tesserae diagonally in quarters.

Cut 5 of Fig. G tesserae in half (see Fig. K – use only one dotted line).

Cut 1 Fig. G tessera in quarters (as shown in Fig. K).

Cut 2 Fig. I tesserae in half (as shown in Fig. L).

Create the Mosaic:

1. To begin setting the tesserae, spread a layer of PVA glue on a small section of the shelf top. (You'll need to "butter" the backs of the larger tesserae with a bit more glue as you go along, but the glue you spread on the shelf should be enough for the little tiles.)
2. Use the project photo as a guide to set the orange and yellow borders on the ends, lining up the edge of the tessera with the pencil line or the edge of the shelf, as required.
3. Set the black and metallic avocado green border, starting at the ends and moving toward the center.
4. Butter the back of a black 7/8" tesserae and set it in the center as indicated by the Assembly Diagram. Continue to glue tesserae, following the design lines and using the project photo as a guide. Allow 24 hours to cure.

Grout:

1. Mix grout with a bit of green acrylic paint.
2. Follow the instructions in the Basic Techniques section to grout the mosaic.

Finish:

1. Follow the instructions in the Basic Techniques section for sanding the mosaic.
2. Apply two coats polymer protectant. Allow each coat to dry for half an hour.
3. Stain the exposed wood. Let dry.

Assembly Diagram

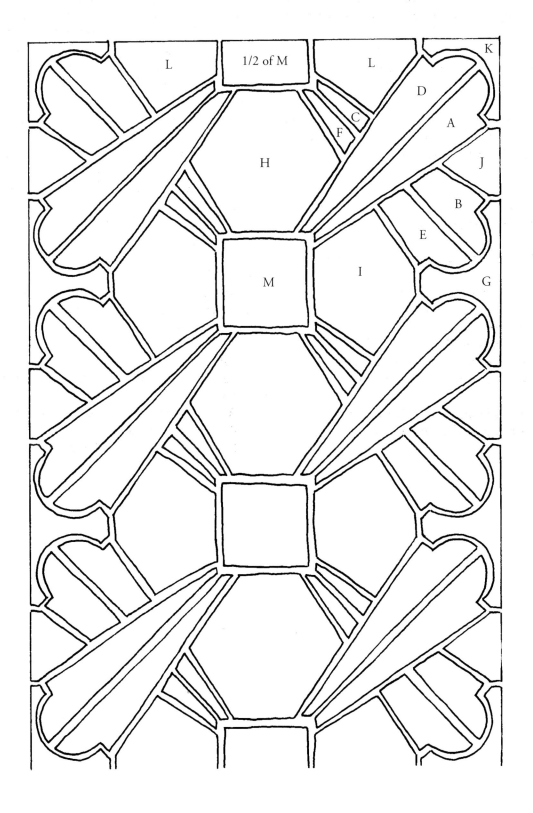

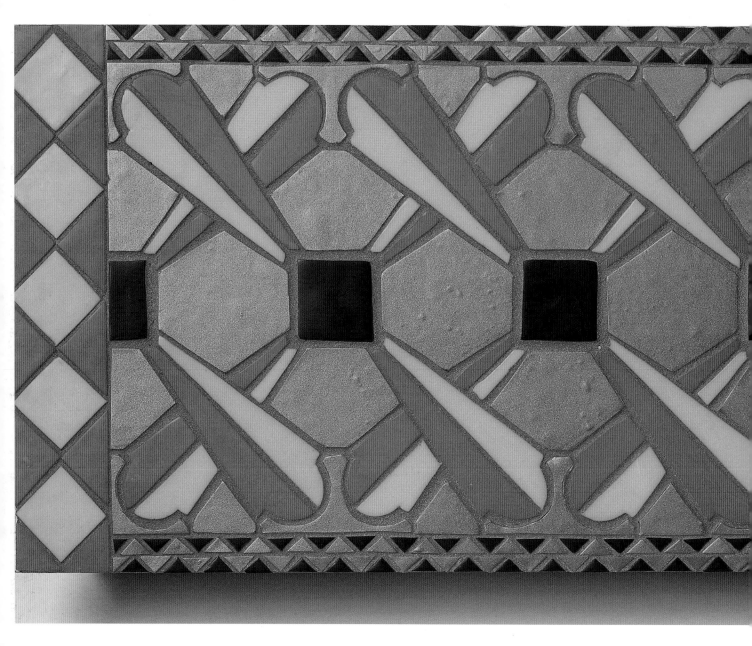

Closeup view - top of shelf.

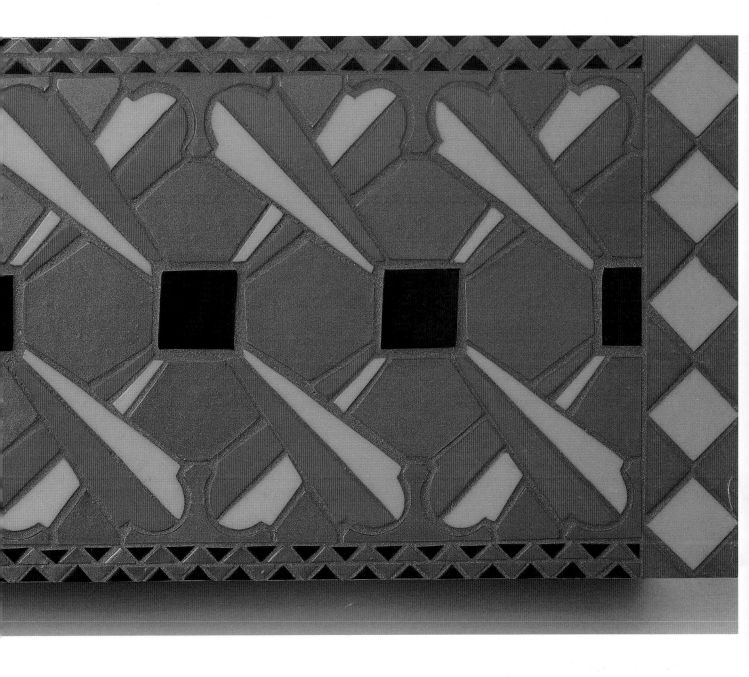

METRIC CONVERSION CHART

Inches to Millimeters and Centimeters

Inches	MM	CM
1/8	3	.3
1/4	6	.6
3/8	10	1.0
1/2	13	1.3
5/8	16	1.6
3/4	19	1.9
7/8	22	2.2
1	25	2.5
1-1/4	32	3.2
1-1/2	38	3.8
1-3/4	44	4.4
2	51	5.1
3	76	7.6
4	102	10.2
5	127	12.7
6	152	15.2
7	178	17.8
8	203	20.3
9	229	22.9
10	254	25.4
11	279	27.9
12	305	30.5

Yards to Meters

Yards	Meters
1/8	.11
1/4	.23
3/8	.34
1/2	.46
5/8	.57
3/4	.69
7/8	.80
1	.91
2	1.83
3	2.74
4	3.66
5	4.57
6	5.49
7	6.40
8	7.32
9	8.23
10	9.14

INDEX

Continued on next page

INDEX

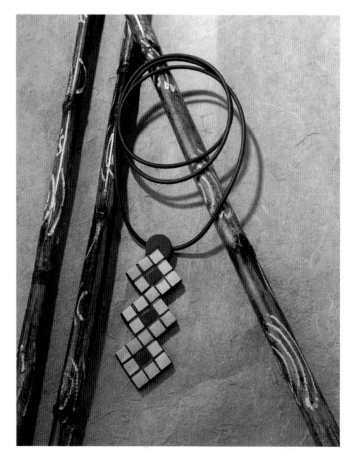